NATURAL LIGHT AND THE ITALIAN PIAZZA
SIENA, AS A CASE STUDY

SANDRA DAVIS LAKEMAN

ILLUSTRATIONS
MARK LLOYD LAKEMAN
JOHN TRAUTMAN - GARY TOM

SETTING
GRAPHICOMP, SIENA

PRINTED
ALSABA GRAFICHE, SIENA

Natural Light Books

PUBLISHER
NATURAL LIGHT BOOKS
1106 Oceanaire Drive, 28
San Luis Obispo, California 93405
United States of America
TEL: 805-541-3223 FAX: 805-756-5986

© Sandra Davis Lakeman 1992

First published 1992
Second Edition 1994

PRINTING in Italy
ALSABA Grafiche, Siena

SETTING in Italy
GRAPHICOMP, Siena

PHOTOGRAPHY and TEXT
Sandra Davis Lakeman

ILLUSTRATIONS
Mark Lloyd Lakeman
John Trautman/Gary Tom

GRAPHIC DESIGN
Jennifer S. Lakeman

The bibliography lists references used in the preparation of this text.

The Library of Congress Cataloguing-in-Publication Data
Lakeman, Sandra Davis
Natural Light and the Italian Piazza
Library of Congress Catalog Card Number: 93-206345

Cover:
Absorption of Light:
Piazza del Campo I, Siena - 1987

Printed in Italy

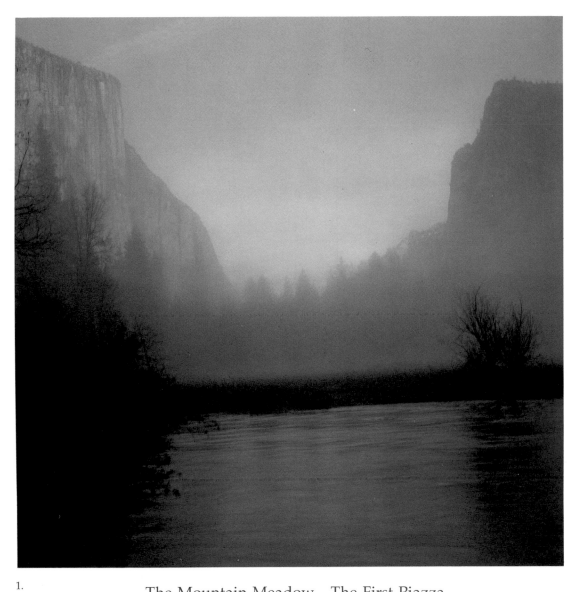

1.

The Mountain Meadow... The First Piazza
"In the beginning, all the world was America"

John Locke

"All cannot live on the piazza...
but everyone may enjoy the sun."

an Italian proverb

Dedicated to the conservation of our earth;
the preservation of our cultural history as expressed
in the architecture of all eras;
and to designers of the future who address factors of aesthetics,
the elements of nature, the sun, the wind, and the rain,
the moon, the stars,
in their concerns for the whole environment.

TABLE OF CONTENTS

PREFACE

Building with light involves the use of wisdom to give a new dimension, a new soul to spaces and places. Sandra Lakeman, with her impressive collection of evocative images and suggestions, has achieved this objective, transforming abstraction into reality. Architectural forms and structures, moments and symbols of an extraordinary urban development touched by light, assume shades of meaning that go beyond simple visual perception, encouraging reflection and suggesting new methods of design.

Siena, the site chosen by Sandra Lakeman as a starting point for her didactic venture, is in effect the model for her research, which examines and explores the relationship between space and light and the way we experience them. The shadows which trace the profiles of architectural elements, the radiance which contrastingly illuminates certain urban spaces, the Gothic forms delineated by the nuances of [light:] at some times [silently] suffused, at others more vibrantly alive than the shimmering night, reveals the Gothic soul of the city more effectively than the most detailed [verbal] description.

Piazza del Campo, the object of a particularly careful study by Sandra Lakeman and her students, represents the never-ceasing play of light that penetrates with varying intensity the differing times of day and the rhythmic change of the seasons, describing its architectural history through time.

And around the Square, dark streets and steep lanes, old walls barely grazed by [reflected] rays of light from the towers and facades of churches and palazzi in a tapestry that is not just the random interweaving of elements over the centuries, but the result of a natural process of urban developmemt.

Sandra Lakeman and her students thus present a new mode of interpretation for the city and its surrounding countryside, its spaces and its symbols in a study which researches the significance of the past while projecting a design for the future.

Pierluigi Piccini
Mayor of Siena

Natural Light and the Italian Piazza

Introduction

In the center of Tuscany, surrounded by a richly varied *campagna* of undulating hills and valleys defined at their crests by *pini* and *cipressi*, with darkened ruins as sentinels of the past punctuating distant views, lies the mystical city of Siena. Washed in the famous Italian *luce* and *ombra*, the earthscape supports this medieval hill town in a symbiotic concert of color and light, in the hues and patina as expressed in the allegorical frescoes of its thirteenth century painters.

Through layers of mist and haze rising from the moist earth, the diffused light reinforces repetitive folds of the earth, and the hill towns which remain have a presence unequaled in the landscape. The variables of the earth are telegraphed through the ever changing heights of the towers and the surrounding structures as they still conform to the lay of this ancestral land. On a clear day, from ramparts of fortified walls and tops of towers, infinite vistas lead as far as the eye can see.

This is the setting in which the urbane Comune di Siena reigns. At its heart, formed by three converging hills and designed in the Medieval Ages by an unusual group of civic minded individuals, can be found one of the most elegant urban open spaces in existence. The distinctive Piazza del Campo is a pictorial diapason of Gothic art and architecture, complete and in harmony with its surroundings. Natural light which abounds in the space, illuminating its beauty, serves to inspire and enrapture those who enter its realm and appears to have been considered in its formation. The *piazza*, a natural amphitheater, is oriented to the southeast. The rich earthen colors encircling the place, variations that only centuries can give, act as a kaleidoscopic patina of light and shadow. The *palazzi*, the tower, the stones, and the Sienese brick seem to have evolved from the earth, and the soft form of the Campo continues to symbolize the mountain meadow it once was. Because of the hilltop site, all of the phenomena of light are manifest within the Campo, making this unique urban setting a supreme natural and built subject for the study of light.

The phenomena of natural light are absorption, diffraction, haze, polarization, reflection, refraction, scattering, and transmission. These all interact in the atmosphere of the Campo. The effects of natural light, namely backlighting, frontlighting, sidelighting, toplighting, uplighting, grazing, washing, diffused, direct and indirect light, are all evident. These are the physical explanations for light. However, when they work in concert with the Campo, they often create "special occurrences." A combination of the light and the place create a seemingly mystical moment, beyond the sphere of the prosaic. The place becomes like a painting with the light illuminating its "vital import" [Langer 1957, p. 59] and one senses an emotional connection. When light brings life and meaning to the Campo, one understands and sees the history, the beauty, and the continuity of life. These are incidents when light interacting with the architecture brings intellectual "insight." [Langer 1957, p. 60] And so, what is momentous about the phenomenon of light in the Campo is that it interprets and defines the intrinsic meanings of this mystical place.

Early in the morning, the light arrives slowly while the sun is hidden, backlighting the massive Palazzo Pubblico with an aura, silhouetting its profile, and emphasizing the commune's political power. When shadows cast by the principal buildings mimic their Ghibelline crenellations on the floor of the piazza, they bring reminders of the past for all to see and walk upon. When the thick concave and convex *palazzi* walls redirect streaked rays of light back into the Campo, they act as city-sized parabolic reflectors, reviving the space.

Each day, the sweeping hand of the tower moves dramatically across the space, painting its image on the *palazzi* facades and the floor of the *piazza* in its task as the city's mammoth sundial. The Campo is tailored after the ancient hemicycle, the interior of a half sphere, with its opening facing upward to the sun. [Boorstin, p. 27] When light makes the past, present, and the future apparent, the meaning of time and the continuity of life is expressed. The piazza floor, a fan-shaped design of radiating lines, gives a historical face to the sundial clock, because it symbolizes "the Nine," the governmental group that led Siena to its apogee. [Cesarini, p. 7] With the dynamic shadow of the Torre del Mangia, the Campo represents the world to the Sienese: the brick made from the clay of the *contado* symbolizes mother earth, the patterned floor reflects their communal history, and the shadow of the tower in its daily path manifests the cycle of the sun in its travels across the piazza, the world. [Lakeman, p. 124].

"Derived chiefly from the external appearance of organic nature," Gothic architecture is valued according to "the image it bears of the natural creation." [Ruskin, p. 100] The Gothic Campo, an atavistic record, physically structured in brick and stone, represents the historic memory of the open field, the mountain meadow, remaining forever in the collective memory of its people. [Cervellati, p. 240] Light transforms the Campo to another time. When light appears to be an "actual substance," [Hewison, p. 59] as when it is held suspended in the glow of an early morning mist, there is a spiritual quality that forms "the link between nature and building." [Hewison, p. 131].

In the drifting mists of an early morning, the Campo symbolizes a lush, moist mountain meadow as the *piazza* floor glistens like the meadow from the morning dew. The surrounding *palazzi nobilitá* are as tall and dark as the encircling evergreens defining the meadow. The pristine Fonte Gaia, clear as a sylvan lake, reflects the transparent sky in the pellucid light, and streams of water, coming from the mouths of stone wolves, refract in sprays of splashing water. The early morning sunrays, almost parallel to the surface of the earth, send shafts of light traveling through clearings in the deep forest, ricocheting off of trees and rocks like the shafts of light coming from the labyrinth of Sienese streets. At the lower edge of the swale the long shadow of a lone *cipressi* echoes across the piazza floor, resembling the tower shadow casting an image of itself across the floor of the primeval forest. It extends over pine needles and bare tree roots, the lines of travertine and brick herringbone patterns of the Campo floor.

Therefore, natural light enlivens the Campo bringing about these special occurrences. So natural light, "as the giver of all presence...is really the source of all being." [Lobell/Kahn, p. 22] As such, in bringing life to the Campo, natural light is the soul of the place. Therefore, the phenomenon of natural light and the architecture of the Gothic civic realm give meaning, "the primary human need," [Norberg-Schulz] to the environment and the lives of its citizens. Within this place, the light evokes remembrances that make this place special, meaningful, and memorable, with such a strong spirit of place that "entering the Campo is like coming home." [Hook, p. 71].

13

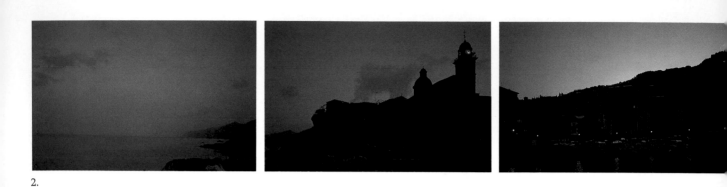

2.

14

Light...
Light is.
Light is the provider of reality,
the giver of presence,
the creator of existence.
Light is beauty.

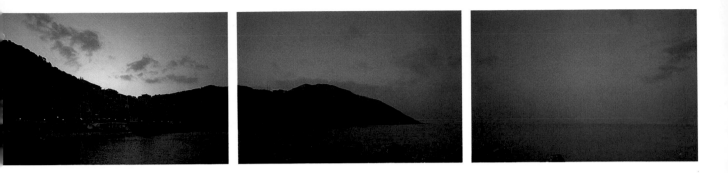

Natural Light

Light paints our world in beautiful shades of color, tones of chiaroscuro and patina enriched by life and time. The light in Italy is famous and a favorite subject for writers, painters, and photographers. It is said that Italy's light is like its wine that changes by region. Hence, the northern light enhanced by the Lombardy Lakes and the Veneto, absorbed by the water vapor is "soft and diaphanous," and in Naples and Sicily, "it takes on an azure brilliance" with a severity that can become "cruelly inhumane." In Tuscany, light is said to be the best, having "eternal youth," always entering the earths' atmosphere at that very moment. [Vandoyer, pp. 9,10] Throughout the day, the beauty of the changing light moves our lives from the commonplace to the profound. It creates opulence or simplicity, excitement or serenity as "illusive" mists and "transitory" vagaries of light nurture the mystery of the infinite and bring beauty and meaning to our lives. [Willis, p. 9].

A shaft of sunlight separates light from dark and makes the realm of lightness special, turning a *space* into a *place*, giving it meaning, comfort, and beauty. Thus, according to twentieth century philosopher of art, Suzanne K. Langer, light is the revealer of "visual reality." [Langer 1953, p. 71]. In the contraposition of light and darkness, black and white, John Ruskin, an authority on Gothic architecture, described shadows created by projections on the lighted facade of a building. "Whatever projections and details exist on the surface turned obliquely to the light, each, however small, has its dark side and shadow, and every one is seen more and more distinctly as the object is turned more and more from the light." [Ruskin, 8:302 n.].

Shadows can also signify the passing of time... evoking space and time, past and future." [Reed, pp. 15,25] For example, Stonehenge, was "designed expressly to create and mark shadows." Yet, "any building or object becomes a kind of sundial whenever the sun shines on it," and it casts its' shadow across the land. [Reed, p. 15].

15

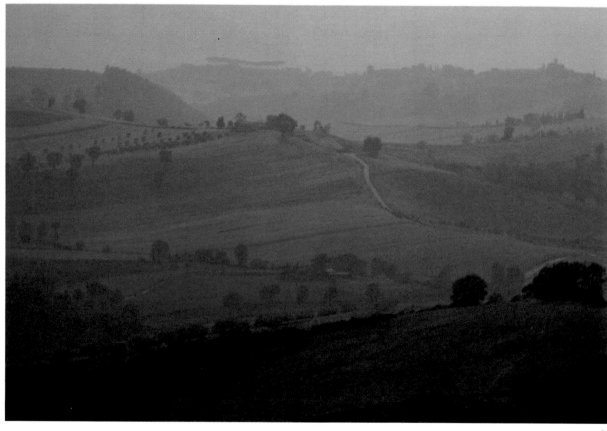

In every culture, people have felt the need to pacify the gods who controlled natural phenomena, possibly bringing destruction or plenitude into their lives. [Cotterell, p. 138] For instance, the dichotomy of light and dark have been represented by Apollo and Ra, the Greek and Egyptian sun gods, and in the Chinese symbolism of the yin-yang. It is the ethereal quality of light and shadow and its effect upon the human condition that is the focus of this *oeuvre*, a serious in-

tent to discover and document the meanings, today and yesterday, of the spiritual and mundane qualities of light and shadow in the Gothic civic realm.

LIGHT IN ART

The Medievals appreciated light and all elements of nature. Philosophers and mystics alike were enthralled by luminosity in general, and by the sun's light, regarding "light as the original

4.

metaphor for spiritual realities." [Eco, p. 46] Medieval theorists saw beauty as quantifiable, but love of light and color was a "qualitative aesthetic experience." [Eco, p. 43,44] To the Medieval Franciscan theologian St. Bonaventure, "Light was the principle of all beauty." Not only because it delights the senses, but because although it was physical, it was fundamentally a "metaphysical reality," providing all the variation of color and luminosity in heaven and on earth. The powerful visionary, St. Hildegard recorded her view of light, "I am that living and fiery essense of the divine substance that glows in the beauty of the fields. I shine in the water, I burn in the sun and the moon and the stars." [Eco, p. 47].

It was also a central focus in the art of the 13th century. "Between 1250 and 1430, Italian artists rediscovered pictorial space and pictorial light" [Hills, p. 3] which the painters of antiquity in

Rome and Pompeii had mastered. "Pompeian landscapes dissolve in a haze of golden light and lavender shadow...the illumination of the moment." [Hills, p. 9] "Since light in nature changes hour by hour, season by season, pictorial light was an important reminder of the passage of time." [Hills. pp. 9,10].

The stained glass windows of Gothic cathedrals gave "the effect of light erupting through an open fretwork," in a "marvelous uninterrupted transparency." [Eco, p. 46] They created "a higher meaning for the architecture and a transcendental, visionary effect," thus acting as a 'glass bible,' spiritually educational. [Trachtenberg and Hyman, p. 232] If light had such importance in art and architecture and was the basis of much of the theoretical thought of the day, then it would certainly have been a consideration in the design of the cities and the urban open places of the period.

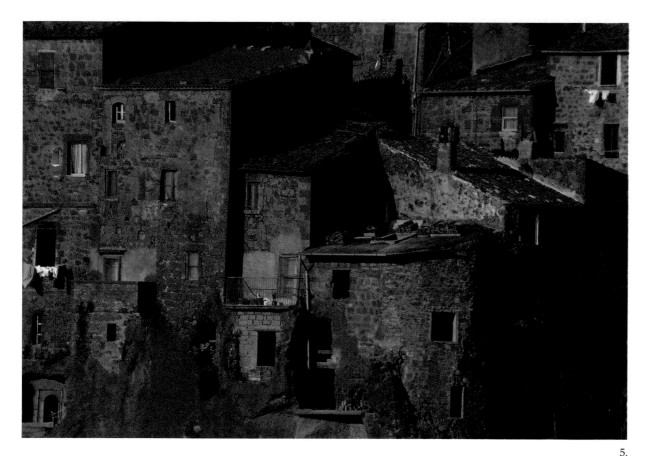

5.

LIGHT IN PHILOSOPHY

According to modern philosophers, light has metaphysical meaning beyond its physical manifestations. Langer, discusses natural light in relationship to artistic perception, expressiveness, insight, and intuition. For instance, in the piazza, light is understood with feelings...and this provides an experiential understanding of the space. [Langer 1957, p. 59].

The 17th century philosopher John Locke was concerned with knowledge, which he referred to as "the light of nature" or "natural light." In effect, Langer states that what she means by "intuition" is what Locke called "natural light." These terms give visual clarity by metaphoric reference to a search for human understanding. Locke's predecessor, Nathanial Culverwell, represented reason, faith, and other human attributes as light. Culverwell used Aristotle's writings to paint a vivid picture of the beginnings of intel-

lect on the *abrasa tabula*, metaphorically using "naturale light" as the Candle of Knowledge. He translated, "set open the windows of sense to welcome and entertain the first dawnings, the early glimmerings of morning-light. [It enters the windows bright in the morning, and extends its light in the narrow crevices.] Many sparks and appearances fly from (a) variety of objects to thye understanding; the minde, catches them all and cherishes them, and blows them; and thus the Candle of Knowledge is lighted...this is the true method of knowledge." [Culverwell, p. 81].

Twentieth century philosopher Gaston Bachelard wrote, "...the image comes before thought," and that art, "rather than being a phenomenology of the mind, is a phenomenology of the soul." Indeed, the soul would seem to possess an inner light, "the light that an inner vision knows and expresses in the world of brilliant colors, in the world of sunlight." [Bachelard,pp. xvi, xvii]

True art and architecture "is therefore a phenomenon of the soul." Since the word soul is an immortal word, its use connotes that the art or architecture which "causes" this sort of an "effect" on the consciousness, is an immortal, timeless work. [Bachelard, p. xvii] Also, this substantiates the connection between light expressing the soul, the life, and the timeless quality of a place. These metaphors of light as the intellect and soul help us understand natural light in urban open space. Natural light in the piazza, therefore, clarifies and represents our intuitions, insights, feelings, memories, and sense of the place. It reflects continuity of time and the immortality of the place.

LIGHT IN ARCHITECTURE

Light is a quintessential element of timeless architecture. If light is "the giver of all presence," [Komendant/Kahn, p. 191] it can be postulated... that natural light is the soul of a place. Its luminosity clarifies the mental as well as the physical realm, the prosaic as well as the poetic, the profane as well as the sacred. This soul is sensed by the observer and leads to immediate knowledge of the space.

In fact, light can also be thought of as a substance, just as when "we think we are perceiving solid objects when in fact all we ever see is light reflecting in different wavelengths from the surface of things... light is often seen as the bearer of revelation rather than the substance of the revelation... but light may just as well be the content, the substance." [Wortz/Turrell, pp. 8,9] In this respect, Natural Light represents in this study the life of the Italian people as it enfolds in their public places.

Ruskin believed that "light...(was) a type of physical beauty which he distinguished from other elements "as an actual substance." Fascinated by two key elements Life and Light, he combined "the physical and the spiritual" in the natural and the built world. Believing that "the natural world is the source of our conception of beauty" he linked nature, beauty, and architecture. He realized the importance of the "spirit" which architecture should exude stating that a structure should have "metaphysical or historical meaning." [Ruskin, p. 170]

Similarly, American architect, Louis I. Kahn said, "A building designed only for need... without windows or natural light, is not architecture," [Komendant/Kahn,p. 27] as, "without light, there is no architecture." [Lobdill/Kahn] And Siena historian Judith Hook wrote, "that the city is the only possible complete form of human existence; that without cities there can be no civilization." [Hook, p. 88]

Therefore, it can be theorized, that without light, there can be no cities, there can be no civilization, there can be no architecture.

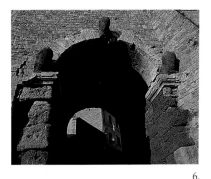

6.

The Italian Piazza

The Italian piazza, the "living room" of the Italian people, is widely considered the most beautiful and distinctive of urban open spaces. Most are uniquely shaped, sized, and oriented in relationship to the terrain, the town's form and size, and the natural elements, the sun, the wind, and the rain. Their continuing success in a changing world is due to the foresight of its designers and the flexibility of their designs.

The first piazza may have been the meadow. Wherever people settled, whether on hillsides or at springs, they left an opening large enough for gatherings. A small circle formed for socializing and survival eventually evolved into a grouping of built forms, the village square, the agora, the forum, and eventually the piazza. The brick and stone structure of the Piazza del Campo in Siena represents the historic memory of the open field, remaining forever in the collective memory of its people. [Cervellati, p. 240].

Recorded in the 1309/10 *Statutes of Siena* is a remarkable explanation of the origin and rationale of the Piazza del Campo. "Among those matters to which the men who undertake the city's government should turn their attention, its beauty is the most important. One of the chief beauties of a pleasant city is the possession of a meadow or open place for the delight and joy of both citizens and strangers, and the cities and some towns of Tuscany...are honourably supplied with such meadows and open places." [Waley, p. 107/Braunfels, p. 208]

HISTORY

Public places have historically been the focus of civic life, the stage for every kind of human interaction, from celebrations, to safe havens during wars, to the casual meetings between friends. The city, "as a symbol of the cosmos," took "on the regular geometric shape of a circle, square, rectangle, or some other polygon." Vertical elements such as the ziggurat, pillar, tower, or dome, served to "highlight the city's transcendental significance." [Tuan, p. 153].

With the Greek agora, the public gathering place, architecture for the first time was used in consideration for the common people, not the aristocracy. Its "esthetic order rested on a practical base...the formally enclosed agora, with its continuous structures, the broad unbroken street lined with buildings, and the theater." [Mumford, p. 207] The mark that distinguished the Roman city from Hellenistic cities of the same general character was the layout of its two principal

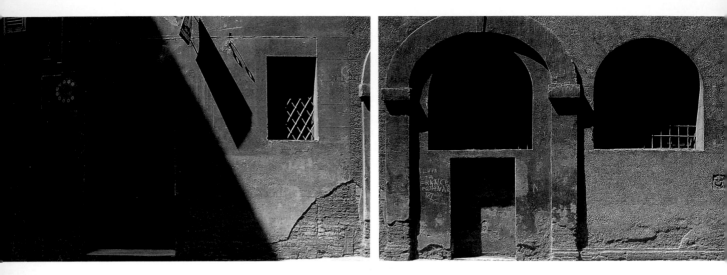

streets, the *cardo*, running north and south, and the *decumannus*, running east and west. In the center of the city where the two major streets crossed "there was the usual - or at least the ideal - place for the Forum." [Mumford, p. 207] The Romans contributed this formal urban arrangement and were the first "to develop a square oriented around a centrally placed monument," which symbolized "the Imperial presence, benefaction, and rule," in the use of axes in "symmetry, frontality, and centralized focus." [Elsen, p. 256].

Most existing Italian piazze were formed in the Gothic Period, from the 11th through the 14th centuries. These urban open places responded to the end of feudalism; the new free-dom was symbolized in spontaneous, irregular forms in contrast to the regular, grandiose fora. The piazze responded to a many-faceted social system composed of a secular administration, working-class companies and guilds, urban nobility, and the church. In some cases, separate spaces developed for the different functions.

The piazze were sometimes a series of linked spaces, possibly reflecting the lines of vendor stalls. Street-like spaces widened and straightened; structures were removed to construct an area along a street; cemeteries were paved to provide forecourts for churches; streams were covered to claim more land; raised constructions claimed new level space in a hill town; natural amphitheaters provided remarkable spaces that defined

the city's character. By the end of the 14th century, all European cities claimed public open places.

DESIGN OF THE MEDIEVAL PIAZZE

Possibly the square's most rigorous planning element was its sense of enclosure. Small openings were allowed usually at the corners, and long range vistas were blocked. Public buildings formed a continuous surround of facades. Even cathedrals seldom stood alone. City halls maintained their prestige with a high bell tower and gathering place in front.

The piazza accommodated a variety of public functions and urban "furniture" such as monuments, obelisks, and fountains. "The ancient rule of placing monuments around the edge of public squares...avoid(ed) vehicular paths, centers of plazas, and, in general, central axes, thereby achieving especially pleasing artistic effects." [Sitte, p. 162].

Medieval piazze vary widely in shape because each evolved from a unique situation. In towns of organic growth, the marketplaces and cathedral forecourts formed irregular figures, sometimes triangular, sometimes many sided, sawtoothed, curved, connected in a series of linked spaces. But their graceful, unregimented form does not mean that they were unplanned. "Organic planning does not begin with a preconceived goal: it moves from need to need...in a series of adaptations that themselves become

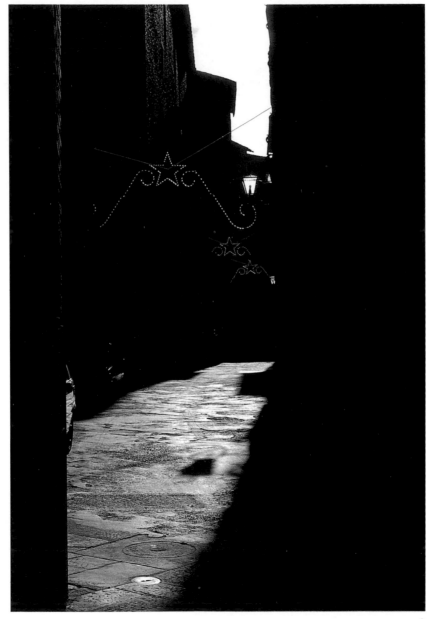

8.

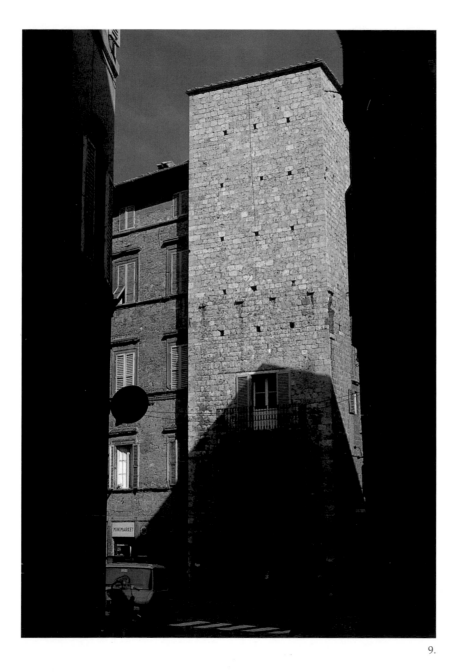

9.

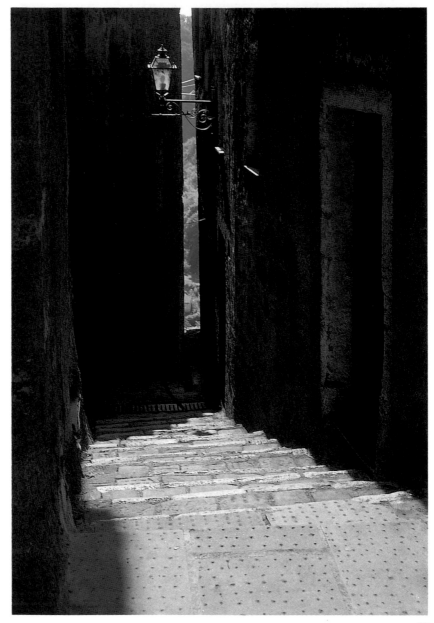

10.

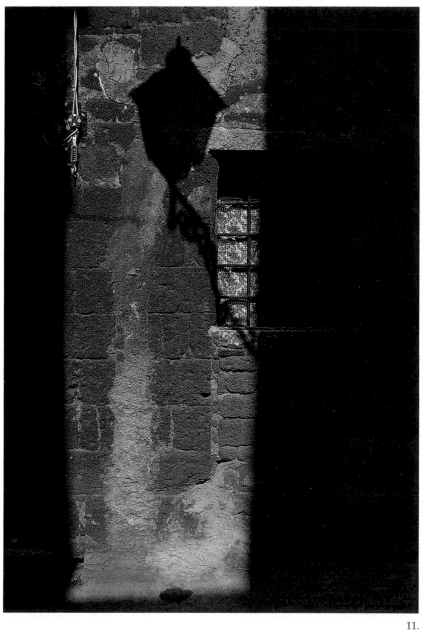

11.

12.

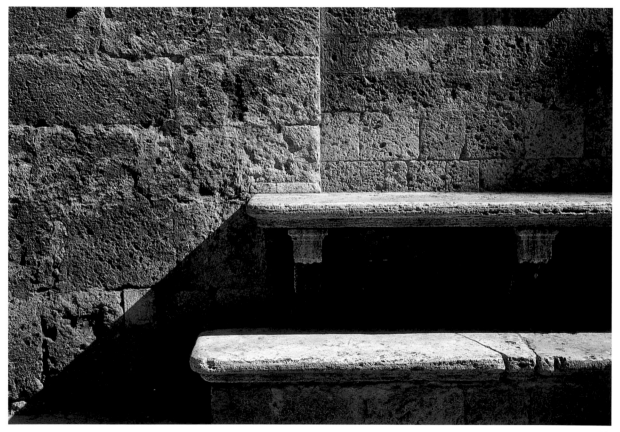

13.

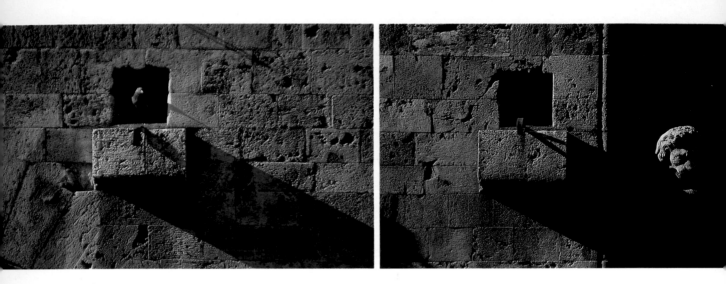

increasingly coherent and purposeful, so that they generate a complex, final design, hardly less unified than a preformed geometric pattern." [Mumford 1961, p. 302].

ARCHITECTURAL THEORISTS

For architecture to have meaning for its people, it must reflect their cultural, social, spiritual and environmental values. Two thousand years ago, Vitruvius considered all these in relating the shapes of towns and piazze to their access and reception of light. In the 16th century, Andrea Palladio, discussed the monumental Baroque style, expressed in broad streets and enormous squares, foretelling the decline of open spaces for the common public in favor of transportation ways of the wealthy.

In the 19th century, Camillo Sitte, the "last of the great city planners" analyzed incrementally developed towns, focusing on plazas, their sequencing, and the importance of contained space rather than the form of the container. He compared plazas to rooms, "since the main requirement for a plaza, as for a room is the enclosed character of its space." [Sitte, p. 170] He determined that the size and shape of a plaza should be proportional to its dominating structures. And he determined that "there are two categories of city squares: the deep type and the wide type...church plazas should preferably be treated as deep plazas, squares in front of town halls as wide ones...and, the size as well as the shape of

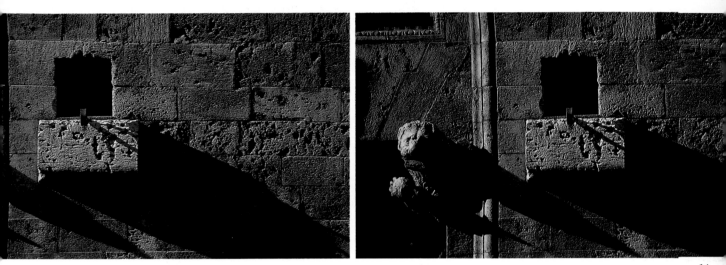

a plaza stands in a proportional relationship to its dominating structures." [Sitte, p. 177, 178] "In addition, particular note should be taken of the placing of the Campanile to one side so that it stands guard at the juncture of the larger and smaller plazas." [Sitte, p. 197] Sitte was concerned with "the strong influence of the physical setting on the human soul", and stated that, "city planning should not be merely a technical matter, but should in the truest and most elevated sense be an artistic enterprise." [Sitte, p. 141,142].

In the 20th century, Paul Zucker saw the square as an essential element of town planning, creating "a gathering place for the people, humanizing them by mutual contact, providing them with a shelter against...the tension of rushing through the web of streets." He wrote, "The unique relationship between the open area of the square, the surrounding buildings, and the sky above creates a genuine emotional experience comparable to the import of any other work of art." [Zucker, p. 1].

And Christopher Alexander wrote, "When we look at the most beautiful towns and cities of the past, we are always impressed by a feeling that they are somehow organic...each of these towns grew as a whole, under its own laws of wholeness...and we can feel this wholeness, not only at the largest scale, but in every detail..." [Alexander 1987, pp. 2, 3].

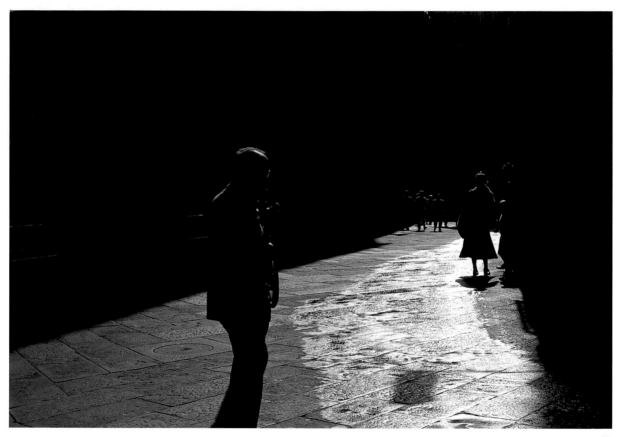

15.

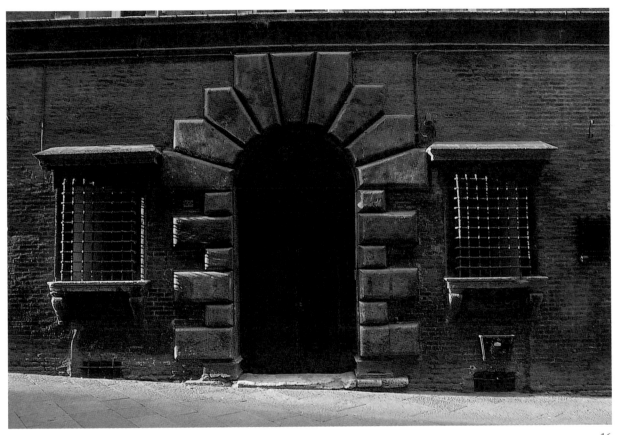

16.

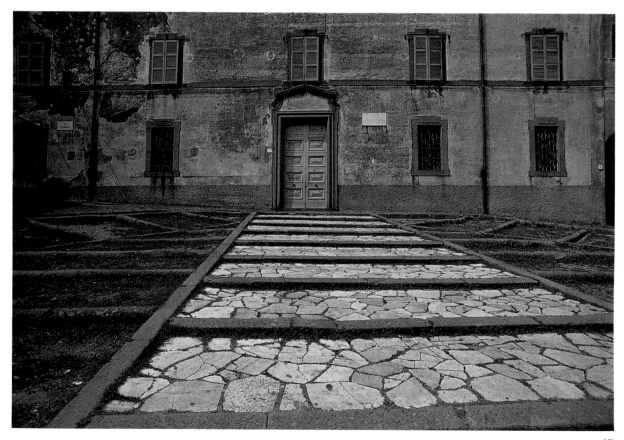

18.

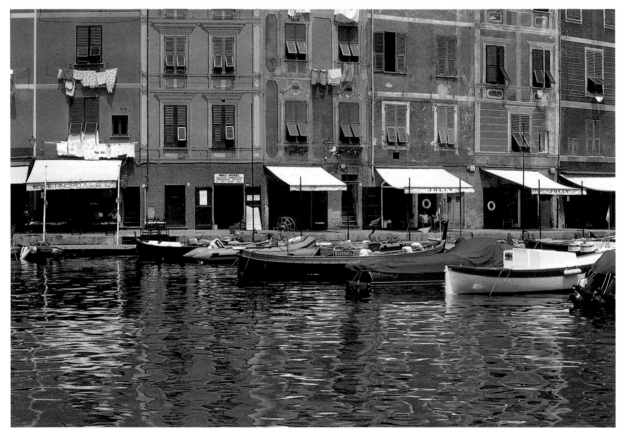

19.

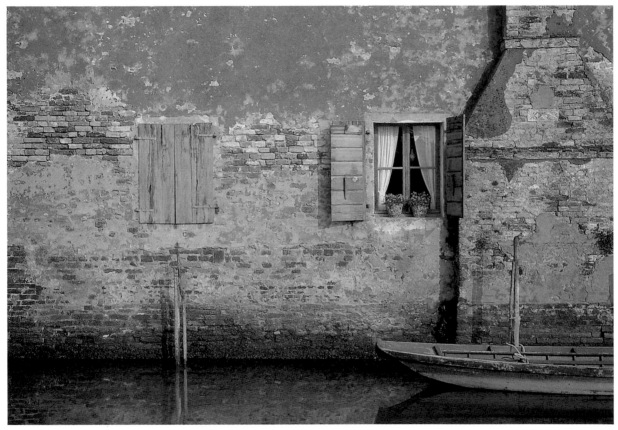

20.

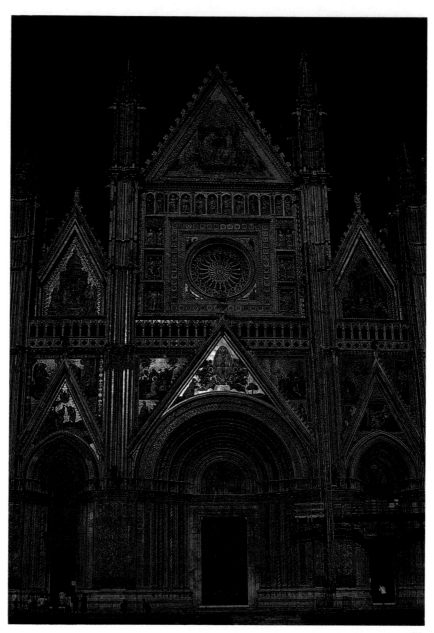

21.

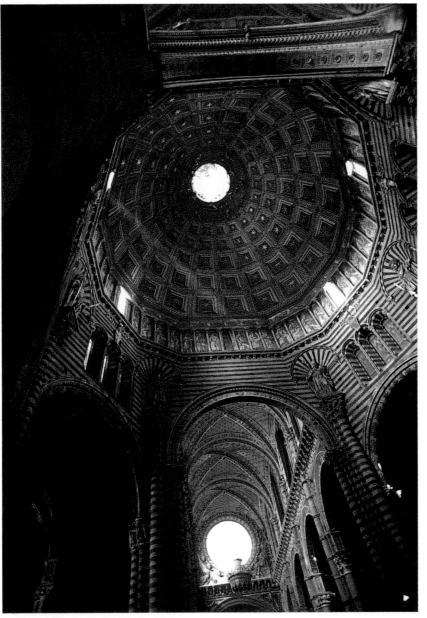

22.

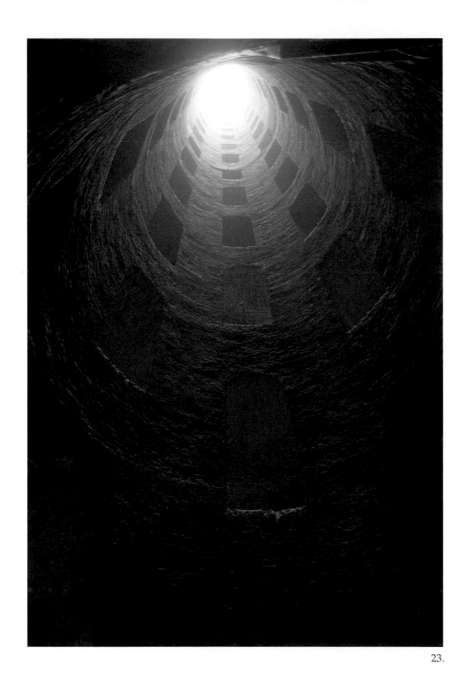

23.

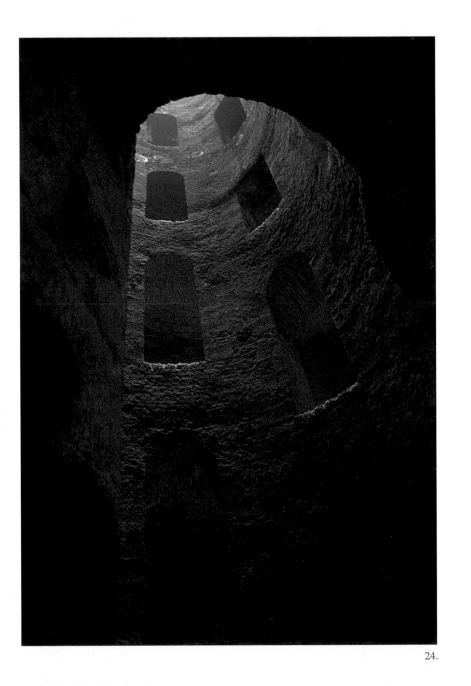

24.

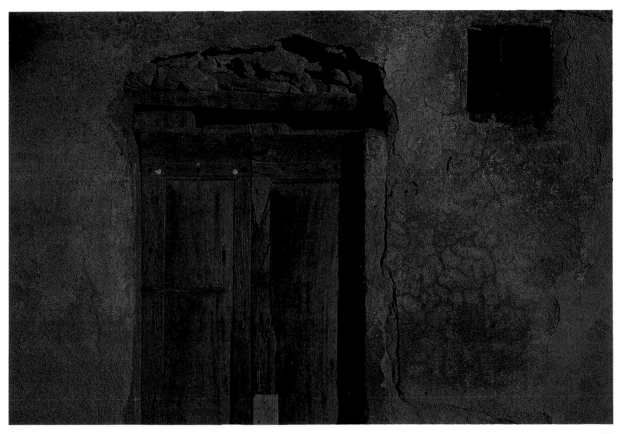

25.

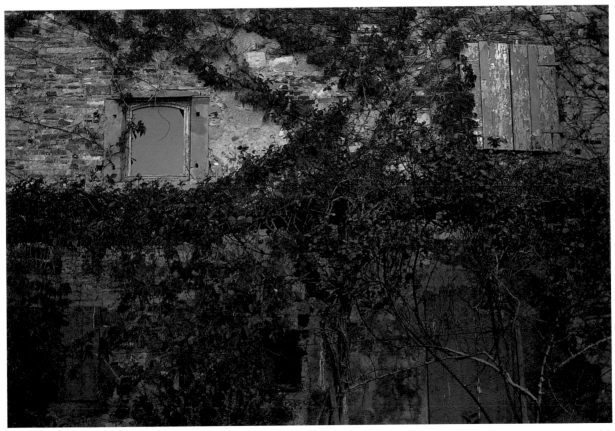

26.

DIAGRAMS OF THE PHENOMENA OF LIGHT

COLOR

HAZE AND SCATTERING

POLARIZATION

MIXED REFLECTION

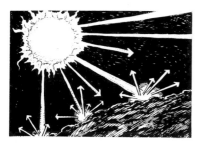

ABSORPTION

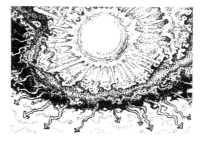

MACH BANDS

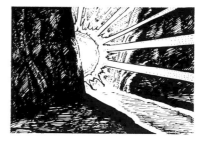

DIFFUSE TRANSMISSION

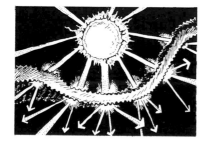

CREPUSCULAR RAYS

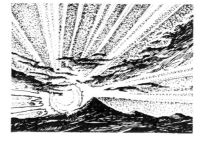

REFRACTION

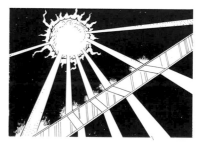

THE PHENOMENA OF LIGHT
Every form of creative expression has its dominant medium.
That of painting is color, of sculpture space,
of dancing rhythm, of music sound.
The dominant medium of photography is light.

Andreas Feininger

To appreciate the beauty of light, we must make a conscious effort to become aware of it. By looking for light, we may develop a sensitivity to all elements of nature: the weather and the time of day. Even nightfall can make us aware of the visual world when we distinguish objects by the shadows and light that touches them. Reflectivity and mirrored images "advertise the presence of light." Cloudy and misty atmospheres reduce perception; diffused light, colored from the sunrise or sunset, gives an unusual coloring to familiar objects, demonstrating the illusory and delightful aspects of light. [Hills, p. 4] Also, combined with sensing mechanisms, understanding the physical properties of light improves our awareness. Like the classic study of architecture, this combines the art and science of light.

Science defines light as "radiant energy which travels through space in the form of electromagnetic waves (and rays)...evaluated in terms of its capacity for producing the sensation of sight." [Westinghouse, 2-1] Light travels in straight lines unless redirected by a reflecting, refracting, or diffusing medium. Its waves pass through one another without alteration, and light is invisible in passing through space unless some medium, like dust, scatters it toward the eye.

The following phenomena describe light's actions, properties, and directions. The examples are primarily located in urban settings to aid the reader in seeing light in both natural and built environments and may be used as a glossary.

Absorption occurs when light is prevented from traveling in a straight line. It may be restricted or completely assimilated by an absorbent substance suspended in the air, decreasing its intensity. It can also be absorbed into a dark hard surface. Unreflective black objects totally absorb light. In a dense fog, rain, or mist, the rays of sun are absorbed as waves of energy pass through atmospheric particles, reducing ambient light and sound in the space, adding a sense of mystery, and bringing elements of nature into the urban setting. In the visually enclosed, shell-shaped **Piazza del Campo**, ambient light enters as if through a large skylight of an interior room. The early morning fog acts like a sponge absorbing light energy from the sun and altering sound waves within the space.

Absorption results in a decrease in the intensity of light received in the space, as well as an alteration in the reverberation time of the sound waves. Absorption lowers the height of the apparent sky ceiling, making the surrounding buildings indistinct and darkened in color and reducing the perceived size of the place. Altered light and sound waves affect the ambiance of the space and make it more intimate. A foggy morning is one of the few times you can feel alone in a piazza.

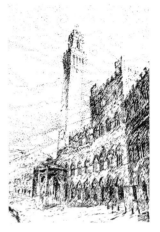

Scattering is the random deflection of light rays by fine particles... reflection, diffraction and interference all play a part in the complex phenomenon of scattering." [Rainwater, p. 50] At noon, the sun is closer to the earth, and the path of its rays is shorter. "Beams of light from the sun are seen coming through the clouds...a searchlight beam sweeps across the night time sky. We see such beams by light scattered from their paths by particles in the atmosphere - usually dust or tiny droplets of water." [Hewitt 1977, p. 475] At noon, the sun is overhead at its zenith. **The atmospheric path** is direct and the shortest path from the sun. On a clear day, the scattering of short blue wavelengths make the sky blue. The more clear the day, the more intense the blue. As the sun sets, the path from the sun is longer, more blue rays are lost in the scattering process, and the sun has the hue of the longer orange and red waves. All objects touched by this light will be affected and have a warm glow.

Color is one of the most remarkable phenomena of light. Its nature is intertwined with the nature of light. "The color you see depends on the intensity and wavelengths of the light reflected or transmitted by the object, on the color of the surrounding objects, and on absorption or reflection by substances in the light path." [Lam, p. 41] Late in the day, sunlight streams across the Chianti valley, enlivening the buildings that line the curved street, and coloring a **curved wall and door of Panzano in Chianti**. Across the valley, the sun is almost level with the distant western ridge and will soon disappear below the horizon. The sunlight has passed through a dense autumn haze rising from the moist valley floor, and the resulting color is from light scattered by the mist and smoke particles in the air. This explains why all of the elements of this image have the same warm glow. They are all being struck by the warm-colored light that has penetrated the haze.

Haze is a product of light scattering by dust, water particles in clouds, mist, and fog, and by smoke particles. This phenomenon makes shafts of light visible. Throughout Tuscany and Umbria, looking across the valleys from high vantage points, layers of haze can be seen making hills and valleys. They appear as folds, exaggerating the perspective depth of the scene. In the **Piazza del Campo, Siena**, urban haze is the predominant condition in which scattering is evident in the urban setting. "When sunlight enters through a crack, scattering by dust particles in the air makes the shaft of light visible." [Rainwater, p. 50] It manifests itself in a thin vapor of fog, smoke or dust in which these particles deflect the light, producing a visible **shaft of light**.

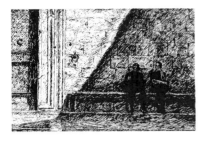

Mach bands

Approximately one hundred years ago, environmental dark and bright bands were reported in scientific literature by the Austrian physicist, philosopher, and psychologist Ernst Mach. Since the phenomenon "depends strictly on the distribution of illumination," and "partly on how our own eyes respond to contrast," it is difficult to judge, "how much of the contrast we perceive is objective and how much is subjective." [Ratliff, p. 92] In Siena's Piazza del Campo the image of **a woman walking along the tower's shadow** may only provide an impression of large areas of light and dark. Notably, however, these people are choosing, perhaps subconsciously, to relate to the demarcation between light and shadow. On closer inspection, the two areas appear distinctly darker and lighter than their respective remaining areas. In the dark shadowed side, as it meets the lighter side it changes "with a narrow dark band at the dark edge."

In the lighter area, the edge also appears to be more intense, with a bright, narrow band at the bright edge. In photography, there are two effects, one real and one an optical illusion enhanced by the photographic process. The phenomenon can also be observed at ground level, such as in the **Piazza Pio II in Pienza** and at the **Chiesa Cristoforo, Piazza Tolomei**, in Siena.

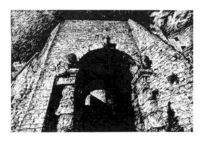

Polarization of light is not apparent to the naked eye. As sunlight passes through the earth's atmosphere, it may be scattered, refracted, or polarized. Light coming from the sun travels in waves and rays, vibrating in all directions, perpendicular to the direction of travel. By polarization, they can be made to vibrate predominantly in one plane. **Porta all'Arco, Volterra** is the famous old Etruscan gateway which still stands as a sentinel overlooking the vast western valley of Cecina stretching to the Carrara mountains and the distant Tyrrhenian Sea. The depth of this gateway indicates the thickness of the walls that still surround the *centro storico* of most of the medieval hill towns. Although each gateway is unique, the Porta all'Arco, in its beauty, is typical of the many which remain. In the photograph, the resultant force of the luminous, sheer, golden light has been controlled by polarization. In the late day sunlight, the colors have been altered by polarization of the rays of the sun, giving a darker patina to these ancient stones and intensifying the blue of the sky.

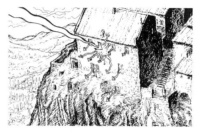

Reflection is the primary light phenomenon, for if light did not reflect off objects and surfaces, there would be no visual world. Without reflection there would be no image or color. The intensity of reflected light on the city form depends on weather conditions, the time of day, and the materials and surfaces receiving the light rays. The level of reflected light is affected by the materials and colors of a city. In **Pitigliano**, the dark stones of the buildings blend into the sheer cliffs of this promontory which juts a thousand feet above the valleys be-

low. When the late day sunlight hits the glass windows, sparks seem to fly from the blinding **specular reflection** and the extreme contrast.

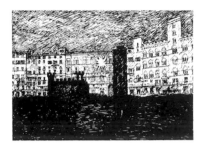

In the **Piazza del Campo, Siena**, the predominant building material is dark. Various rough surfaces create the **diffuse, spread**, and **mixed reflections** throughout the streets and piazze. Occasionally when the sun is at the same angle as the viewer to a reflective surface, specular reflections manifest themselves, creating an unusual incident, such as that on the **northern wall of the Piazza del Campo**.

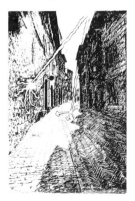

Glare is any brightness of light which interferes with vision, causes eye fatigue, discomfort, or even temporary blindness. Glare is common in the dark, narrow streets of hill towns, and it increases rapidly the greater the difference between the levels of the ambient light and the light source, the sun. The surface texture of the **Via del Castello, San Gimignano**, is a smooth, shiny, elongated brick pattern. This is a good reflector of light as the mortar joints are almost flush with the surface of the brick and do not contribute deep shadows. The smooth floor and the low ambient light level create high contrast and promote glare, regular or specular reflection.

Refraction is the bending of a ray or wave of light as it passes at an angle through one transparent medium to another. Refraction adds flavor and accent lighting in urban spaces. It is evident in the water of ornamental public fountains, such as the **Fontana Maggiore, Perugia**, and in certain panes of thick glass windows. When water gushes from

the jets of a fountain, splashing in the air, the sparkles are caused by refraction. In nature and in the urban setting, "sparkle and glitter are experienced over time and produced by movement. Without movement, they simply do not occur." [Katz, p. 31].

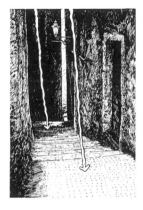

Transmission occurs when light rays pass through transparent or translucent materials. In transmission, light may be scattered, diffused, refracted, or polarized. Light transmitted throughout a city's streets varies with site, topography, orientation, elevation, latitude, longitude, street arrangement, weather conditions, and time of the day. The transmission of light at city scale is exemplfied in street scenes of **Siena, San Gimignano**, and **Pitigliano**. Windows have historically manipulated the transmission of light in practical and symbolic ways. Ordinary, colorless windowpanes transmit all colors of light equally.

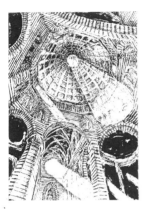

In colossal religious structures, such as **Il Duomo: Santa Maria della Assunta, Siena**, transmitted light defines the structural elements and the space within. The streams of light through stained glass windows indoctrinated the illiterate with visual stories of glory and salvation, giving a transcendental essence to the place, convincing some that the church and the city, were indeed heaven on earth.

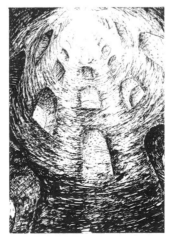

Twilight phenomena and rays of light provide beautiful images when the evening sky is filled with wondrous displays of color, as when clouds hidden from view cast shadows across "the evening sky, like a huge fan." [Minnaert, p. 275] These rays, called crepuscular rays, emanate from one source, the sun, and "radiate from the imaginary point ...where the sun is," [Minnaert, p. 275] as in the **Pyramids of Tuscany**. "These crepuscular rays are visible only where scattering particles float in the air." Just as the colors of a sunrise can be seen best in the east, "the crepuscular rays can more readily be seen near their vanishing points than in directions at right angles away from (them)." They can remain present and "visible long after the purple light" has gone. This is "proof that these twilight rays are always present, contributing appreciably to the light of the western sky." [Minnaert, p. 276].

Direct light following emission from its original source, has not been altered by filtration, reflection, refraction, or scattering. It is predictable. "Constant and identical to that of its source," most importantly it "is light that casts clearly defined shadows." [Feininger, p. 131] **Indirect Light** "follows a broken line from light source to reflector to (subject) before it is reflected into the eye or lens." [Feininger, p. 143] The two images of the 15th century **Pozzo di San Patrizio** in **Orvieto** show the difference between direct and indirect light. In the first case the light comes directly from the source, the *oculus* at the wellhead. In the second image, the light source is hidden, and reflects off of wall surfaces before bouncing through the archway, reaching the lens and the eye.

51

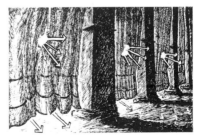

Diffused light is characterized by a scattering action, the breaking apart of light waves in different directions. When the light reflects off a rough surface or is transmitted through a translucent material, "dif-

fused light casts only ill-defined shadows or none at all." [Feininger, p. 133] Light also picks up color from the diffusing medium and casts it on the image. Umbrellas and urban drapery are frequently used to alter the elements of nature, especially the sun. In Vigevano, the crisp white umbrellas contrast with the rich earthen colors of the architectural surround. The colonnade in **Piazza San Marco, Venezia**, flaunts a decorative set of heavy urban drapery for protection from the glare caused by reflected light from the piazza floor and from the seasonal driving rains.

THE DIRECTIONS OF LIGHT

Categorizing light by its directions of travel and analyzing the perceived differences provide additional information in the appreciation of light. Although "light is at once universal and illusive, consistent throughout the height, breadth and depth of space," it gives visual clues about the orientation of surfaces as it "establishes changes of tone as changes in the orientation of a surface." [Hills, p. 3,4].

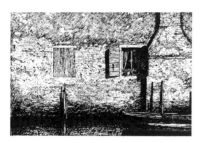

FRONTLIGHTING: (WASHING)

The light source, the sun, is behind the viewer and usually slightly to the left or right, as **In wall along the Canal, Torcello.** The illumination is relatively straight on and the results are even and flat. The subject appears to be washed evenly with light. Thin shadows without much interest appear on the right or left, respectively. Light from a cloudy sky gives a rather diffused, soft light.

SIDELIGHTING: (GRAZING)

As in the **Palazzo Chigi and the Seat Edict, via di Città, Siena**, the light source is to one side of the subject. Sidelighting can be a lateral light that "appears to illuminate approximately half of each solid and casts a long shadow beside it," [Hills, p. 9] cutting an object in half with the shadows created. In grazing, the light source is nearly parallel to the surface of the architectural element and can come from any direction. The resulting light emphasizes the wall textures and architectural forms and can create a dynamic effect.

HIGH SIDELIGHTING

As in the **Palazzo Magnifico, Siena**, the light source is above the subject and aimed at about a 45° angle to it. This is the classic angle in portrait photography; in architectural photography, light at this angle, reinforces the object by emphasizing its three-dimensional form.

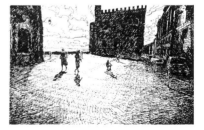

BACKLIGHTING AND SILHOUETTE

The light source is usually slightly behind the subject and directed to one side or another, as in the **Palazzo dei Consoli in Gubbio**. It creates dramatic results, emphasizing

the monumentality of the structure and providing an effect of symbolic power. Cast shadows of large architectural objects, such as towers, emphasize this effect. A lighted background also outlines the object, making a silhouette.

Light reflected from the front surfaces of the subject may illuminate detail or reduce the contrast between the dark foreground and the lighted background. This high contrast may produce a "halo" effect, another form of Mach Band.

CAST SHADOWS

Shadows cast by objects located behind the viewer suggest a concept of time, providing a continuity with the past, present, and future. The lamp post casting its shadow on an ancient wall in the small alleyway of **Pitigliano** sets the scene for a sense of time, the fourth dimension.

TOPLIGHTING

A light source directly over the subject creates exaggerated shadows under projections, textures, and facets of the subject, as with the **Girl on the Steps of the Duomo, Montepulchiano.** The light is a grazing light when located parallel to the plane of the subject. If the source is slightly forward of the frontal plane of the subject, this lessens the contrast and illuminates subject details. Because the world is usually lighted from above, toplighting is familiar, but it can also be used for dramatic purposes particularly when the light source is almost parallel with the reflective plane.

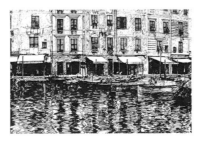

UPLIGHTING

Uplighting is normally artificial unless sunlight reflected from light colored surfaces or water is strong enough to cause this effect, as in the **Piazza Marinara, Portofino.** Though rare, uplighting is particularly effective in architectural scenes, because the most important elements can be selectively emphasized, such as an arcade of supporting columns or arches superimposed on the facade of a building. It also can set the mood, from mystery to power, exaggerating the monumentality of a structure, defining the repetitive structural elements or emphasizing the formal integrity of the building.

53

THE DESIGNER'S PALETTE

The designer considers three kinds of lighting. **Ambient** light is the overall illumination that permeates an environment. **Task** lighting is an individually positioned source, enabling a person to work without visual discomfort. It is usually confined to a small work area. **Accent** lighting is the exciting light that sets a mood, adding drama or beauty to a scene; in nature, like a beautiful sunrise sending horizontal beams of sunlight through a dewy mountain meadow; in the built world, it can be the specular reflection that bounces bright light into the piazza off of a simple glass window.

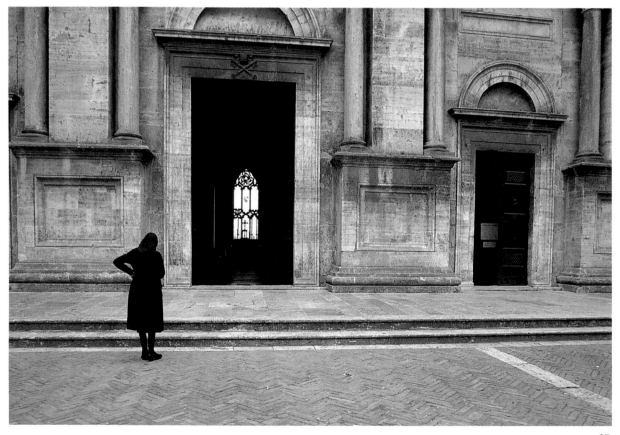

27.

Siena as a case study

During the thirteenth and fourteenth centuries, Siena gained considerable political importance, and the citizens must have possessed an extraordinary civic pride, they were convinced that no other Italian town had more beautiful buildings, streets and squares.

H. Keller, 1965.

The interaction of societal, economic, political, cultural, intellectual, spiritual, and artistic elements are visible in Siena's architectural vocabulary. Most importantly for natural light are the commune's planning decisions regarding its relationship to the topography and orientation to the sun. For livability, its size, perfect for pedestrian accessibility, and the actual orientation of its streets and open spaces to the sun are critical. Because of its attitudes of *urbanistica*, green belt and no-growth, pedestrian-only policies, Siena is still one of the most beautiful cities in the world. Good planning and responsible guardians have protected this 'living museum.'

Siena's organic form indicates that it must have been seen as a cohesive entity by its builders. It may have originally been a cluster of circular walled villages sited on the ridges of three hills. The pathways that connected and curved around them gradually developing into today's street system. [Brogi, p. 17] The Sienese incorporated the Roman principles of law and order and cardinal and theological virtues, which blended with the urbane Etruscan character, resulting in the much cherished citizenship of the city-state. Siena reached its apogee under the rule of "the Nine," a secular regime, in the 13th and 14th centuries. [Cesarini, p. 7] In 1340, the influential Gothic painter, Ambrogio Lorenzetti "first clearly referred to the relation between culture and society." [Larner, p. 1] His *Allegory of Good and Bad Government* depicted contemporary political ideals, reflected in town and landscape panoramas still commanding the interior of the town hall. "The civilization of the city was dependent upon a particular society and its just and ordered government." [Larner, p. 1] That spirit was responsible for the development of the entire city and is still apparent in citizen involvement today.

The common architectural style during the height of the commune rule was Gothic, different in Italy from the Gothic of the rest of Europe. In its religious structures, the austerity of the Cistercians blended with the "poverty, simplicity and humility" of the Franciscan friars. [Jan-

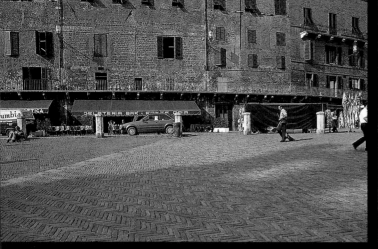
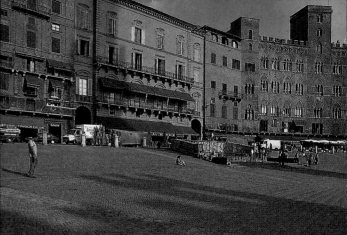

28.

son, p. 303] Siena's democracy, surrounded by a grandiose fortified wall was unhampered by defensive requirements," hence, developed graceful ornate structures like the Palazzo Pubblico. Thus, Siena's architecture expresses its social institutions: the *campanile* of the cathedral and the *torre* of the town hall, symbolize the Medieval power struggle between church and state. Two examples which represent "the Nine," are the crowning of the Palazzo Pubblico with nine merlons and the paving of the Campo floor, divided into nine segments. Siena is the physical expression of all of the factors of a noble society. Siena, "is still to a considerable extent the expression in physical form of the cultural values of the medi-

eval urban mind; the articulation in stone, brick, and marble of a medieval view of the world." [Hook, p. 6].

The Piazza, "like the Town Hall.... belonged to the citizens, to all without distinction, while the palaces round it all belonged to noble families, bankers and merchants. The financial and social aristocracy of Siena was concentrated round the hub of civic life; the Piazza was still and always the property of all the Sienese." [Cairola & Carli, p. 33,34] Writers through the ages have extolled its merits, as did Girolamo Gigli, in 1722 when he stated an essential truism of the Campo, "our piazza has been created with so magnificient a symmetry, that anyone, at the first glance can tell

whether the person he seeks is there." Upon its completion, an early chronicler recorded in 1347: "It is held to be one of the most beautiful of all squares which can be seen not only in Italy but in the whole of Christendom, both for the loveliness of the fountain and for the beauty of the buildings which surround it." And in 1398, in a petition to the Council of the Popolo, admiration was expressed, "in every well-governed city, provision is made for the embellishment and the improvement of that city, and you have in this Campo of yours...the most beautiful square that can anywhere be found. [Hook, p. 78].

The ultimate use of an urban space, is the use which maximizes all facets of the place. In the Pi-azza del Campo, it is possible for a person completely alone in total contemplation, to enjoy all of its attributes. This may be the ultimate use of the space for many people individually. But if volumes of people and implied meanings are the criteria, then the 'Palio' is the quintessential usage. To most, the Palio is the ultimate use of the Campo and the streets and other *piazze* of the city, which are utilized in its staging and implementation. It is a celebration of complexities and profound significance in the lives of the Sienese. "The Palio has been and continues to be the dominant event and ruling passion of Sienese life." It has "continued to evolve through the centuries," [Falassi, p. 185] inextricably inter-

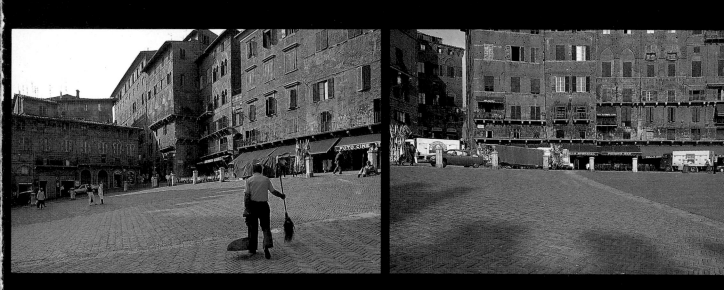

twined within the social structure of the *"contrade,* the town's districts."* [Carli, p. 114] Following the traditional Palio parade, it is befitting and compelling that the Palio race commences with the last light of day.

LIGHT IN THE PIAZZA DEL CAMPO

The Campo's southeastern orientation and curved side walls allow sun into the space early and late in the day. Solar access was probably a determinant of its shape. Historically the most successful site orientation is usually toward the cool morning sun, the southeast. Further proof that the Campo was intentionally sited to relate to the sun is apparent in its site orientation. The

major street of Siena which connects the primary gateway, Porta Camollia, with the area around the Campo, Croce del Travaglio, the intersection of the three primary streets, is oriented to South 17° East. The Campo, however, is at a much more extreme southeastern angle, at South 34°50′ East. Within the Campo, the Torre del Mangia is off-center and sited to the eastern side of the Palazzo Pubblico which allows its shadow to be cast onto the open space and not onto streets and structures in the town. In the early morning, while the sun is hidden, east light backlights the Palazzo Pubblico and the Torre del Mangia, and gives the Campo a soft glow. Only gradually do shafts of light touch the piazza floor as shadows

of the principal structures stretch across the space. In winter, when the sun is at its lowest, the shadows are even on the northern wall of the Campo. Because of their height, these walls receive the first direct rays; and due to their shape, they act like a giant parabolic reflector. Early in the day, light grazes the eastern walls, casting long shadows from small projections on the facades. As the sky clears, direct sun from the south washes with an even ambient light. In the late afternoon, the western sun grazes parts of the shaded facade of the Palazzo Pubblico and the whole western side of the space is in shade. The sun's low rays intensify the Campo's earthen colors and as in the early morning, but from the west, shadows echo patterns of surrounding structures on the pavement. In the evening, the light gradually changes, reflected from the sky, with only the top of the tower accented by the sunset.

In the large open atmosphere of the Campo, light may be scattered, refracted, or polarized. As it strikes the dark stone and brick of the architectural surround and piazza floor, much of the light is absorbed, and what light is reflected is warmed in color from the earthen hues of the bricks. As light strikes the walls, it also enters into the rooms and doorways in the architectural surround of the Campo, as the Campo acts as a giant light well within the city fabric.

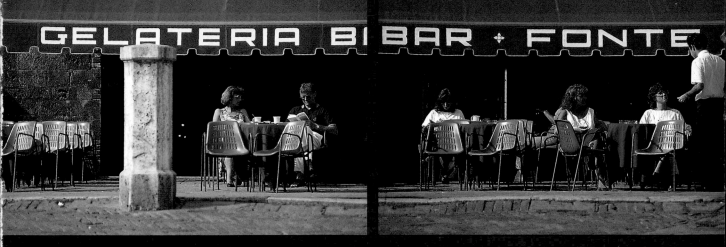

In the reflection of light from the surfaces within the Campo, specular, diffuse, and spread reflection all occur. The absorption of light into the dark walls and the piazza floor is observed in seasonal and environmental haze. On foggy days, the mists drift across the sloped space absorbing and diffusing the early morning light. The light is transmitted directly and indirectly, depending on the weather. All directions of light can be observed from morning backlighting of the Palazzo Pubblico, to the frontlighting of the cafes to the north, and the grazing and washing of the surrounding walls. Refracted rays of light become accent lighting and occur in the tryglyph windows of the Palazzo Pubblico and in the droplets of water coming from the mouths of wolves in the Fonte Gaia.

Through light, one senses the soul of Piazza del Campo. In the special incidents when shafts of light stream across the moist Campo floor and pigeons flutter through the space, or when the tower's shadow inches across the space, time is visible, and the immortality of the city, palpable. Because light is an ethereal substance, it cannot be a captive, yet without it there is no existence. Light is like the fragile but necessary breath of life. Light is the spirit of the place. And in the Campo, the light, the spirit, is for everyone.

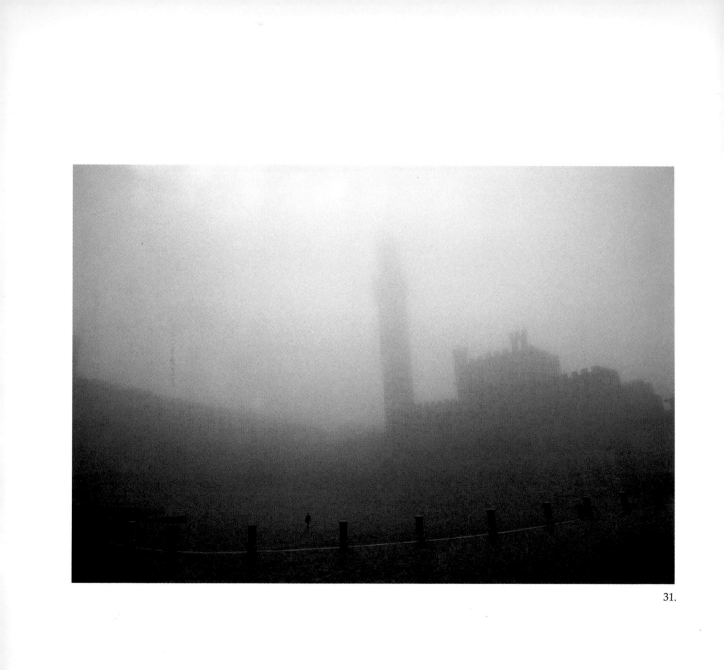

31.

32.

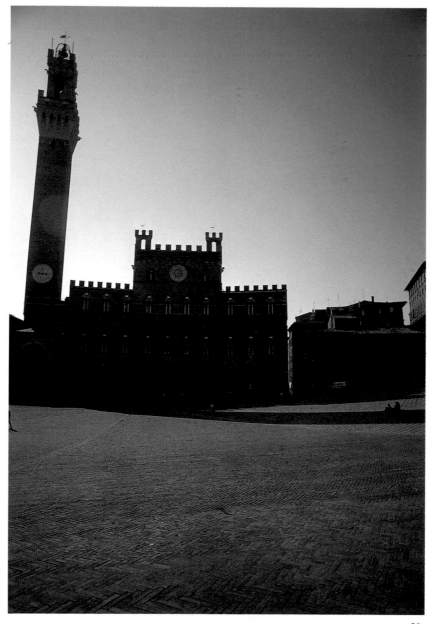

33.

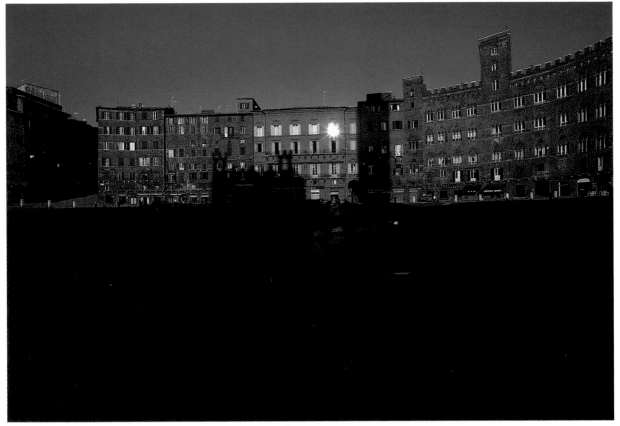

34.

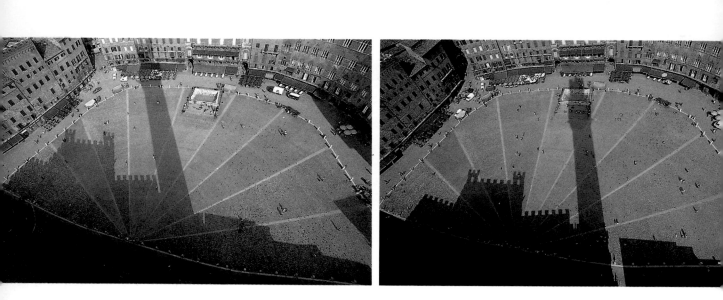

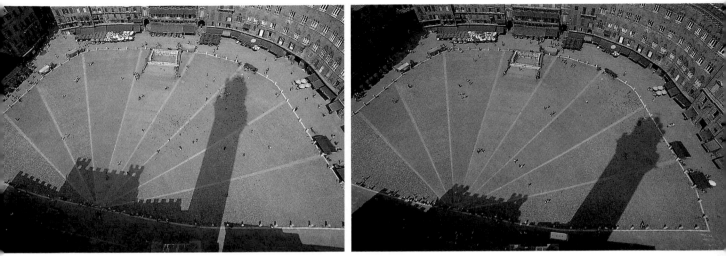

35.

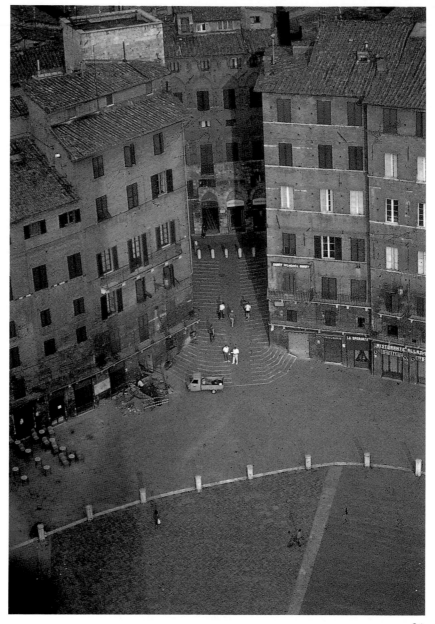

36.

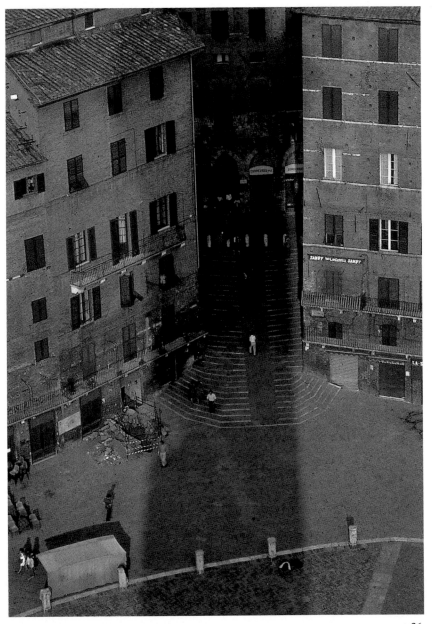

36.

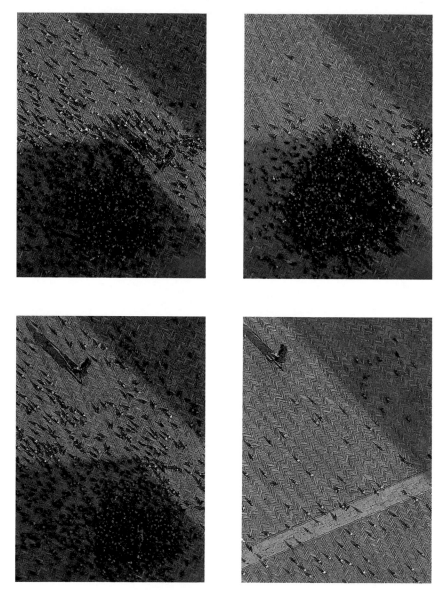

37.

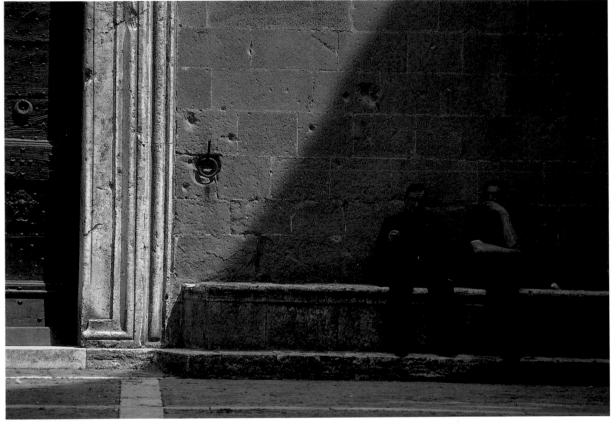

38.

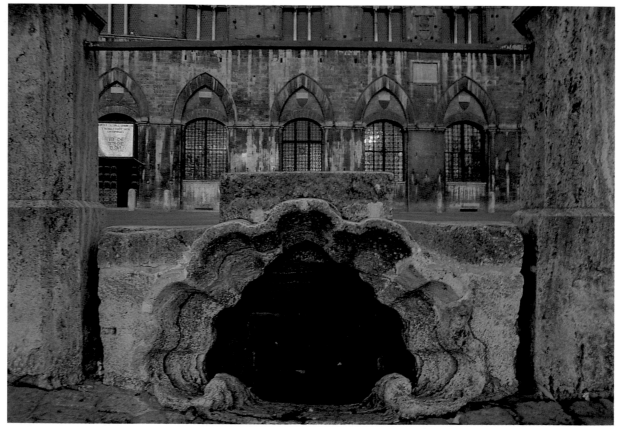

39.

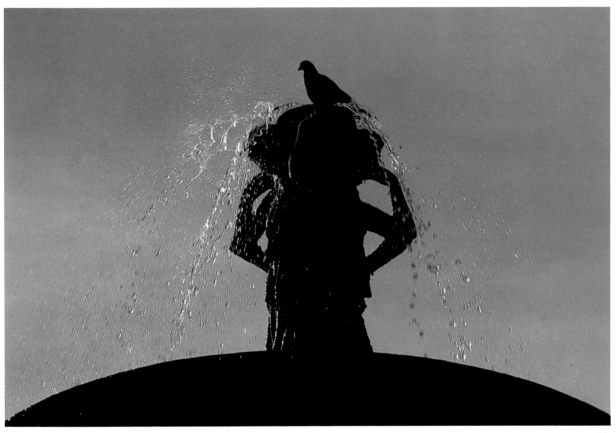

40.

41.

42.

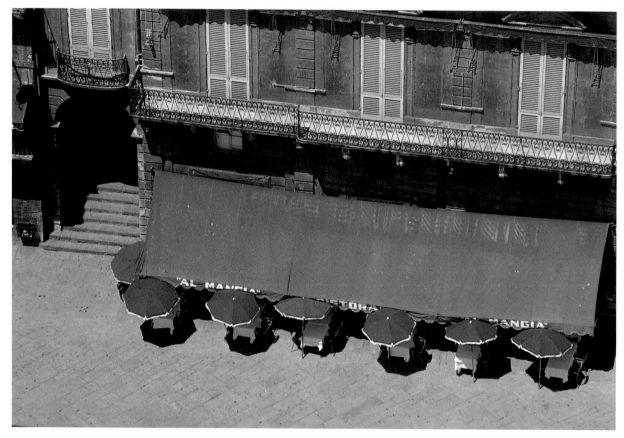

43.

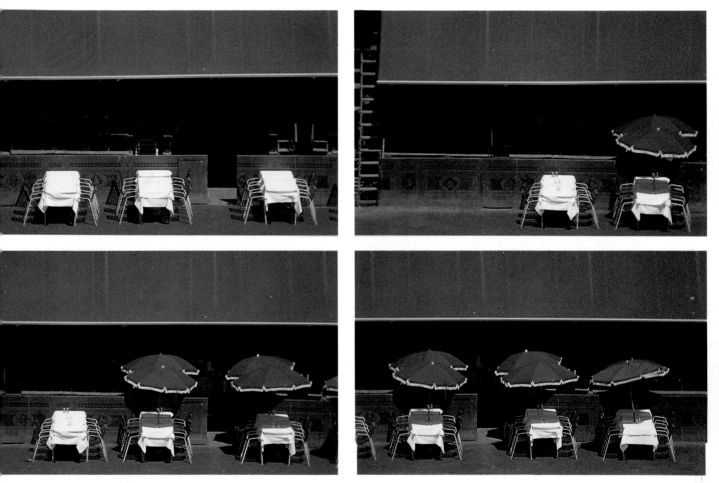

44.

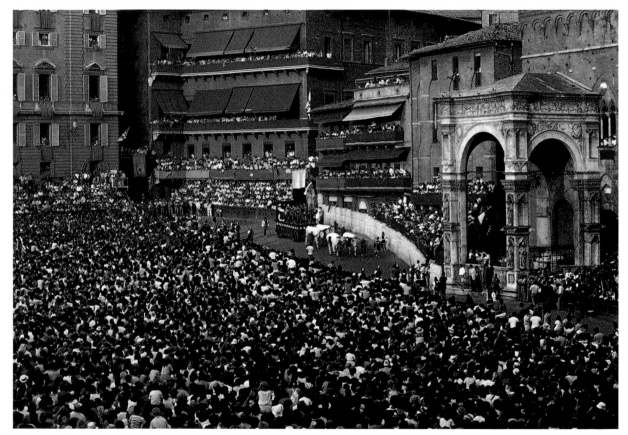

45.

46.

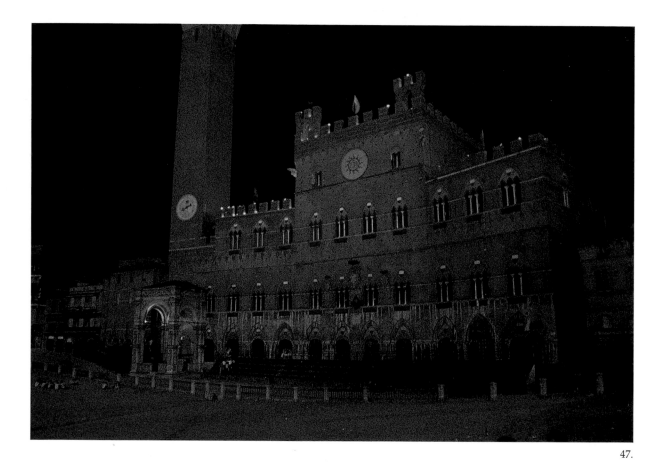

47.

Manifestations of natural light in the Italian Piazza

It is apparent that medievalists, in siting their cities, found ways to address successfully the use of natural light. Over long periods of time, these builders determined the best exposures to the sun and made the most of the basic elements of nature in relationship to their structures. Some argue this occurred by chance, but whether light was considered is not relevant, because we can nevertheless learn from the excellent results. "It would be as mistaken...to assume the presence of a reasoned process, as it would be to assume its absence." [Chambers, p. 221].

Organized from large to small scale, this compilation of research represents a wide variety of examples emphasizing the importance of site orientation, the shape of urban space, the placement of buildings and monuments, the location of tall structures, the augmentation of natural light by shutters, awnings, umbrellas, and urban drapery, and the interactions of people in relation to light, shade, and shadow. It is synthetical of the many towns and piazze of Italy, whether they may be classified as *On the Water, On Flat Land*, or *On Hillsides* most have a site orientation to the South and usually toward the preferred Southeast.

SOUTH AND SOUTHEAST ORIENTATION

In the founding and the placement of ancient towns and cities a study of their orientation shows a preference to orient major city forms and open spaces to the south, and usually to the southeast. Early fishing villages such as **Porta Giglio** and **Portofino** had an initial concern for the selection of a protected harbor. Portofino functioned as a port for naval vessels, and with its harbor and **Piazza Marinara** focused at South 45° East, this sheltered port is of unique size and configuration. Since the bay projects deeply into the colorful town, and the slightly sloped piazza floor melds itself gently into the bay's dark water, there exists an ever-changing, unusual light condition. During the day, the mellowed patina of the facades of the *palazzi* is richly reflected off of the surface of the water. Late afternoon daylight, intensified by the rich earthen colors of the *palazzi* facades, creates a warm glow within the entire urban space.

EAST-WEST ORIENTATION: CITY FORM FACES SOUTH

The city forms extended east by west gain the most sunlight throughout the city, especially on hillside sites. If the principal open spaces are parallel to the east by west streets, they also gain and sustain the most light throughout the day. **Pompeii**, the sumptuous ancient city buried by a disastrous volcanic eruption, offers evidence of a remarkable city plan. The city is raised as if on a large podium. Its streets are oriented southeast by northwest and southwest by north east, a large basket weave of parallelograms. With this plan, there

will always be streets throughout the day receiving direct rays of the sun in a manner that will distribute "**shafts of light**" through the city. This configuration gains much more light than a north-south grid. **Ascoli Piceno** lies in a narrow valley with its broad expanse directly focused to the south and the major *cardo* and *decamannus* streets generally at 90° to each other in a softened grid system reflective of the Roman camp layout, the *castrum*. With minimal sunlight due to high mountains to the south, the city has been extended from east to west to gain the maximum light for the most inhabitants.

NORTH-SOUTH ORIENTATION: CITY FORM

Generally elongated north-south oriented hill towns gradually developed from *castels* of small family groups located on the tops of ridges. Whether they settled there to defend themselves or to escape malaria or summer heat in the lowlands, they chose sites advantageous to viewing the surrounding terrain and for good reception of natural daylight. Examples of hill towns with their principal streets and major contiguous open spaces, usually located on the hill ridges, are, as follows: **Perugia**: Corso Vannucci, Piazza Italia, and Piazza IV Novembre, **Siena**: Piazza del Campo, Piazza Tolomei, Piazza Salimbeni, and Piazza Matteotti, and **Urbino**: Piazza Rinascimento, Piazza Ducal Federico, and Piazza Repubblica.

REFLECTIVE NORTH FACADE: NORTH-SOUTH URBAN SPACE

Frequently in a long rectangular space with a north-south orientation, a major structure, located at the north end, taller than the other surrounding buildings, reflects light from sunrise to sunset, lengthening the hours of daylight in the town's "living room." [Kidder-Smith, p. 47] In **Ascoli Piceno**, at the north end of the space sits the Gothic Chiesa di San Francesco, which regally culminates the piazza in a transverse position. In conjunction with the shiny marble floor of the piazza, in its imposing height and light colored travertine, the broad expanse of the church extends the length of daylight hours in this formal piazza. In **Todi**, the cathedral sits at the top of an enormous flight of steps, facing the south at the end of the narrow **Piazza del Popolo**, the constant light reinforcing its imposing severe nature.

NORTH-SOUTH: TWO-WAY VISTA

Few *piazze* provide views into the countryside, but in defensive **Pitigliano**, an unusual piazza, stretching across the entire promontory which is the city, opens at each end to a two-way vista a thou-

sand feet above the valley floors below providing access for light into this stone eyrie. It is, in fact, impossible to detect exactly where nature stops and the city starts as the blend of medieval building, Etruscan tombs, Roman caves, and the natural *tufa* rock, make "the division between nature and art...invisible." [B.S. Solomon, p. 113] **Piazza del Repubblica** spans across the entire promontory, opening to breathtaking vistas at both ends. Due to its height and freestanding nature, this promontory receives light directly from the south and reflected light from the northern sky. Late in the day, Pitigliano can be seen with low light rays of sun shining through the thick Lazio atmosphere, casting a warm light across the entire town, with scintillating reflections bouncing off the windows, as if the sun were playing jazz on a medieval scale.

URBAN OPEN SPACES: EAST-WEST VERSUS NORTH-SOUTH ORIENTATION

A review of two spaces of opposite orientations can prove informative particularly if one of them has an east by west orientation and the other a north by south. Such is the case with the **Piazza Garibaldi**, Sabbioneta 45°00′ North / 12°29′ East and **Piazza Navona**, Rome 41°54′ North / 12°30′ East. Although, Piazza Navona is a much larger space than Piazza Garibaldi, its plan is very long and extremely narrow and combined with its north-south orientation its exposure to light is greatly reduced throughout the entire year. Though Piazza Garibaldi is further north and smaller, it receives much more usable light due to its east-west orientation, the configuration of this well proportioned space, and its highly reflective northern wall.

SOUTHWEST ORIENTATION: VISTA EXPOSURE

Four prominent towns that face southwest may have selected this orientation for visual access, an unusual consideration in the Middle Ages. **Assisi, Cortona, Gubbio, and Volterra**, have all developed esplanade spaces, which receive large amounts of sunlight and beautiful vistas overlooking the countryside. Etruscan **Volterra**, dark and austere, described by D.H. Lawrence as "a sort of inland island...isolated and grim," enjoys a luxurious esplanade as its principal urban space, **Piazza dei Priori** is surrounded by very tall and dark stone structures. "From time to time...we come to the edge of the walls and look out into the vast glow of gold, which is sunset, marvelous, the steep ravines sinking in darkness, the farther valley silently, greenly gold, with hills breathing luminously up passing out into the pure, sheer gold gleams of the far-off sea, in which a shadow perhaps an island, moves like a mote of life." [Lawrence, p. 144]

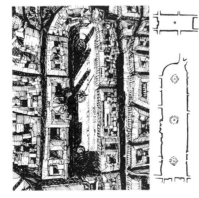

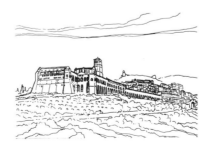

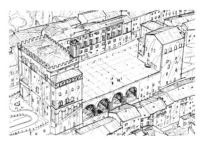

Girded with ramparts, the Umbrian town of **Gubbio**, a hill town with extreme slopes and stairs, constructed a fine, level piazza for its imposing Gothic Palazzo dei Consoli and an incredible view directly to the southwest. Supported by four massive arches which rise above the rest of the town, the **Piazza della Signoria** imposes a severe rectangular opening in this organic town as it clings to the steep slopes of Monte Ingino. It is truly the heart of the town, providing a central gathering place. The piazza introduces a large patch of sunlight into the town, but above all it provides a magnificent view of the Umbrian hills and valleys and rooftops of the town below.

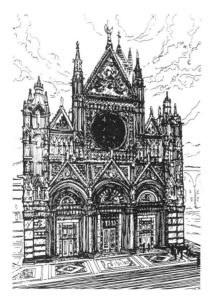

SOUTH, SOUTHWEST, WEST, NORTHWEST, ORIENTATION: REFLECTIVE CATHEDRAL FACADES "FACING THE SUN"

Further evidence of awareness of sunlight in early times are the monuments of antiquity, like the Egyptian pyramids, whose very existence stemmed from a physical relationship to positions of the sun. Awareness of light is also seen in a symbolic relationship to the east in religious structures. The most important event in the day for primitive cultures was the rising of the sun which ended the reign of the dark, if only for the reassurance it gave them, as, "for most of the human centuries night was a synonym for the darkness, that brought all the menace of the unknown." [Boorstin, p. 26] In Christian churches, the apse or altar was placed at the east end, and the ornate facades of the Gothic churches were placed facing primarily south, southwest, west, and northwest. This provided an opportunity to create a beautiful object within the city because the church reflected, sometimes from gilded facades, the warm light of the late day sun and could be seen for many miles around. Many Italian towns took full advantage of this and invested in richly ornate facades, detailed with reflective gold leaf. "Gothic illumination, means something more than the presence of divine light. It implies clarification and understanding,

and is concretized in architectural terms as a logical structure resulting from the interaction of light and material substance." [Norberg-Schulz, p. 111] The following is a partial list of cathedrals which greatly influence the beauty and the lighting condition of their communities.

REFLECTIVE CATHEDRAL FACADES:

South	Southwest	West	Northwest
• Sabbioneta	• Orvieto	• Loreto	• Firenze
• Todi	• Perugia	• Lucca	• S. Gimignano
• Ascoli Piceno	• Siena	• Milan	• Vigevano
	• Spoleto	• Pisa	
	• Venezia		
	• Volterra		

SHAFTS OF LIGHT:
LINKED SPACES, WINDING
AND CONCAVE STREETS

One of the strongest testimonies to the "practicality and aesthetic sensibility" of medieval urban designers "is the linkage they made of disparate squares to achieve economy and beauty of open space in or near the town center." [Elsen, p. 261] This provides spaces unique to each town and an opportunity for **shafts of light** to travel from one space to another. Light is an essential ingredient in the success of the **winding streets** of medieval hill towns. As the sun moves, it radiates through the streets, sometimes only touching surfaces for a few **moments**. This gives an ever-changing beauty to the place as **shafts of light** interject themselves all along the curved streets. The light is usually a **grazing** sidelight, with the source at times parallel to the surface of the wall. Because the walls are curved, the light rays are very noticeable in their distinctive rounded patterns and movement. On a cold day, even a few **moments of sunlight** wakens and warms a dark Gothic street. Another beautiful manifestation of light typical of medieval hill towns occurs when **shafts of light** project into large open spaces from small streets and between linked contiguous spaces. They cast long shadows, which mimic the shapes of the surrounding structures and the labyrinth of medieval streets.

Sometimes between linked spaces, such as in the **Piazza della Cisterna**, in **San Gimignano**, shafts of light are cast in the form of arches on the piazza floor. **Todi** has two linked spaces, **Piazza Garibaldi** with its open vista to the sunrise and **Piazza del Popolo**, the main gathering place. In the morning, light from the east is cast through the open balcony in Piazza Garibaldi, grazing the facades in Piazza Popolo and people congregate at the juncture of the two spaces.

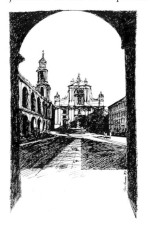

The **Piazza della Madonna**, forecourt to the great Basilica, in **Loreto**, provides a perfectly proportioned setting for a monumental building. As the only enclosed urban space in the town, it also acts as a gathering space, in particular for the pilgrims, the terminally ill, their families, and caretakers. The town's curved main street, via Boccalini, empties into the formal piazza space, integrating the small structures of the town and the Baroque architecture of the Santuario. It also provides dynamic lighting. From the west, late, low-angled, warm-colored **shafts of light** enter the piazza, stream across the piazza floor, the fountain, and the raised monument of the Pope, and bathe the ornate Baroque facade. In the evening great rows of people in formal ceremonies fill the steps across the entire facade as the warmed light enriches the scene.

85

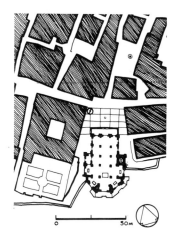

SHAFTS OF LIGHT: PIENZA'S PIAZZA PIO II

Bernardino Rossellino, architect to Pope Pius II formed the slightly irregular trapezoid of the piazza through the placement of structures which stand free of each other on the southern side of the space. This reinforces the importance of the central cathedral, flanked by the Palazzi. "The old Priors' Palace (which) was set at an angle of eighty rather than ninety degrees; and the Palazzo Piccolomini (which) had to be placed at a seventy-five-degree angle," [Mack, p. 99] frames the cathedral. Through the slots, views are granted of the beautiful Orcia Valley and Mount Amiata beyond. But an important factor provided by these splayed walls and formed slots is the light that enters from the east, west, and south orientations, giving a variety of **shafts of light** throughout the day and year. Close to the wall of the Palazzo Piccolomini near the northwest corner of the piazza is Rosselino's handsome public well. Within the **shafts of light** provided by this arrangement, the well receives sunlight early in the morning and throughout the afternoon. "The wells location force(d) the citizen of Pienza to come to the Piccolomini Palace for a basic supply of water." [Mack p. 104] More likely the experience occurred at times when the sun was warming the space.

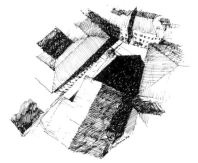

The light from southern openings makes the piazza a more successful urban space. The intentions of this construction are well documented by the benefactor of Pienza. The *Memoirs* of Pope Pius, Rossellino's client, provides evidence of his awareness and "overriding concern for illumination." [Mack, p. 75] In descriptive writings of his Pienza palace, he stated, "if as some think, the first charm of a house is light, surely no house could be preferred to this one, which is open to all points of the compass and lets in abundant light not only through outside windows but through inside ones looking on the inner court and distributes it even down to the storerooms and the cellar." [Pius, p. 285].

SHAFTS OF LIGHT: WINDING STREETS

The streets of hill towns wrap the slopes in parallel contour lines, and connecting streets are softly blended in at a gradual, accessible angle allowing unusual light patterns to enter the curving streets. Occasionally, a street is perpendicular to the contour, but then it usually becomes a *stramp* or stair ramp. The pattern of the streets of medieval hill towns, "was in no way arbitrary; it was the result of events or of orientation, and it complied with the configuration of the terrain." [Sitte, 198].

WINDING STREETS: SIENA

The importance of winding streets to Siena is exemplified by its internal skeletal structure, which was at its apogee, reinforced by over fifty towers, "lofty symbols of noble power." The various noble *consorterie* constructed at the heart of each *consorteria* a place of "refuge, defence and prestige," and they were "clustered along the principal thoroughfares which ran along the ridg-

es of the hills on which Siena was built." [Hook, 10] With its economic reliance upon the Francigena Road, the major trade route of Italy, Siena ultimately earned the title, "sister of the road," as she fed and housed the sick and weary travelers in her hospices. [Stopani, p. 9]

As with most hill towns, Siena can be a cold and windy city, although the curvature, height, and narrowness of its streets can decrease the effects of the wind. Siena is on a variable site yet, "the winding streets of Siena respect the contours, but intersect them at intervals to open up **a view**." Additionally, they insert **light corridors** within the generally dark streets, which drop "steeply in flights of stairs, to serve as pedestrian shortcuts." This interplay of pedestrian right-of-ways and streets for other means of traffic, should act as a classic in city planning. It "demonstrates admirably the esthetic and engineering superiority of an organic plan," implemented for the quality of the environment, rather "than the maximum number of saleable lots and the minimum exercise of imagination." [Mumford 1961, p. 423] Streets have similar uses as piazze. This is true in via di Cittá and Banchi di Sopra in **Siena** where shafts of light interject life into the tall dark streets. Where the curvature of the street changes the lighting condition, light follows the curve of the street, and gives only **moments of light** along the facades, providing

an exciting contrast of light and dark conditions.

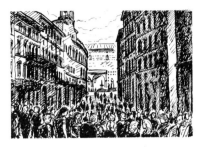

CONCAVE STREET: PERUGIA

A unique situation exists in the Corso Vannucci giving light and visual access from the street to the raised **Piazza IV Novembre**. This elongated street is **concave**, enough so that the Duomo, the statue of the Pope, and the Fonte Maggiore are always within sight. At the opposite end, from the viewing steps at the top of the street, one can see the entire Corso as it recedes into the distance where the countryside is visible through the opening at the end of the street. "The desire to set off a well-designed building or a natural feature is surely the reason for concave curves in old streets." [Sitte, p. 203]

THE EFFECTS OF FLOOR SURFACES

Street surfaces and piazza floors are finished with a variety of materials, usually warm **brick**, dark **stone**, seldom highly reflective **sand**.

The resultant lighting condition will depend on the climate, time of day, and the colors of the materials.

Warm tones augmented by brick surfacing are desirable as they contribute to the ambiance of a place, such as the brick herringbone pattern in **Siena**, and the *spina de pesce* of **San Gimignano**.

Stone, whether light or dark, creates a more formal atmosphere, such as in **Ascoli Piceno**, where the piazza floor is light and highly polished from wear, and in **Volterra** where it is dark and oppressive. Sand can create uncomfortable glare as in Palmanova.

The four primary floor forms for piazze: flat, concave, convex, and sloped, act as city-sized reflectors. **Arezzo** is a prime example of a sloped floor; **Gubbio** a flat; **San Gimignano** a convex; and **Siena** a concave. The subtle differences between these various forms contribute significantly to the character, ambiance and usability of these spaces.

Flat and sloped floors direct sunlight out of the space. The parabolic concave and convex floors reflect light back into the space, with concave tending to keep the rays more within the space.

87

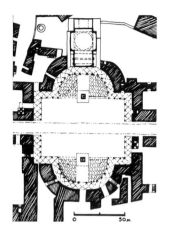

OPTIMAL SHAPE: GEOMETRIC PIAZZA
PIAZZA ANNUNZIATA

The optimum urban piazza shape should be judged by its form and the manner in which it receives light, but ultimately its success is measured by how it is enjoyed or ignored by its citizens, the physical conditions undoubtedly contributing to its success. The formal Piazza Annunziata of Venaria Reale near Torino, beautiful in its Baroque configuration, is possibly the optimum shape for a geometric piazza. The center rectangle is elongated on the east-west axis, and the north-south axis has extensions of semicircular porticoes. These are major receptors of extra light. For example, at the most extreme situation, winter solstice, from 10 a.m. through 2 p.m., one half of the pi-

azza floor is still in light. During the summer solstice, this aristocratic space is almost totally in light from 8 a.m. through 5 p.m. and from 6 a.m. until 6 p.m., one fourth of the floor is always in light.

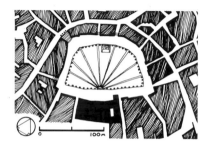

OPTIMAL SHAPE: ORGANIC PIAZZA
PIAZZA DEL CAMPO

Most medieval urban spaces appear to have developed from widenings in the road, or a triangulated intersection of streets. Consider the major spaces of the historic centers of Perugia, Massa Marittima, San Gimignano, Cortona, Assisi, and Siena. Only one, the Piazza del Campo, in Siena, stands apart as a form that evolved from an organic origin with a clearly determined shape. Due to its form and orientation, the Campo provides a setting for all human social amenities and manifests unusual lighting conditions throughout the day and year. The Piazza del Campo in its half-round plan and one-quarter round section, in

its duplication of the shape of the world and the cyclical system of the cosmos, receives natural light as perfectly as any structured space. With the sloped curve of the piazza floor, the splayed walls of the architectural surround opens to sunlight. Although it is sensed as an amorphous space, orthographic drawings demonstrate powerful geometric relationships.

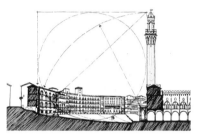

A square proportion is implied in the relationship between the height of the tower and the depth of the piazza, as shown in section. This is the rule stipulated by the architectural theorists Alberti and Camillo Sitte. It appears that, although the Piazza del Campo is of medieval design, it fits the criteria specified for perfect Renaissance proportions. Measured on the diagonal, the significance is shown between the tower in relation to the major entry and viewing corridor, the via Costarella, reinforced when the shadow moves across the opening to the large ramped entry way.

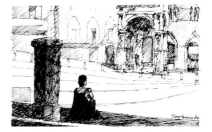

THIN TOWER: SOUTH-SLOPED URBAN SPACE

There are certain distinct lighting conditions which exist in the Campo. The major one is the shadow projected by the **Torre del Mangia**, which casts its shadow like the hour hand on a clock. This effect, combined with the slope of the piazza floor and the juxtaposition of the tower location, offset from the north arrow in relation to the half circular piazza, has a significant impact on the ambiance of the space. People can be seen interacting with the tower shadow, enjoying its shade in the heat of summer, and avoiding it in the chill of winter. They can be seen lounging in it, reading the newspaper on a regular basis, sketching, contemplating, pushing the baby buggy in and out of the light and shade, meeting friends there, having lunch, 'people watching.' Only the tourists sit in the shadow as the Campo is sacred to the Sienese.

The success of any piazza can be measured by the varieties of activities which the space supports. In the Campo they are infinite and span from individual contemplation to group activities, such as, guitar music, juggling and magic shows, staged performances, fireworks cascading off the town hall, and the famous 'Palio' celebration.

The massive Palazzo Pubblico and lofty Torre del Mangia, located on the low south side of the space, bring the height of the civic structures down more to the level of the people who congregate on the high sides of the piazza. The flat area on the high side of the space's perimeter, provides plenty of room for sunning in cafes and restaurants and observing the civic complex to the south. The north-facing Palazzo Pubblico is almost always in shade, except late in the day, emphasizing the mystery and power of the Commune. This architectural ensemble expresses civic power and prestige, meanings of time, and the continuity of life.

CRENELLATIONS: SHADOWS OF THE PAST

The profiles of structures are cast as shadows on the ground and wall surfaces of the **Piazza del Campo**, imprinting the historic past momentarily upon the present. The shadows cast by the civic structures remind one of the past. In towns all over Italy, the profile of Ghebelline or Guelph crenellations remind one of that struggle. In Siena, 'the Nine' is immortalized, and the shadow of the tower reinforces the power of the Province of Siena. It inspires a nostalgia for the past and a stirring of civic pride for the beauty and prestige of the city. Today it is possible to see people walking along the many permanent and impermanent lines on the Campo floor. Children run down the lines of travertine, people walk along the shadow lines of the tower and the town hall crenellations. This is "tracking," a subconscious tendency to walk along an implied line. If the lines have purpose and meaning, this is

89

an opportunity for designers to enrich a townscape for future generations.

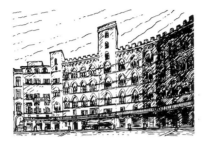

PARABOLIC REFLECTIVE WALLS

The northern elevation of the architectural surround of the Campo has a parabolic shape as it encircles the space. Beginning early and throughout the day and evening, this continuous curved wall reflects light back into the space, affording more surface area, hence reflecting more light than from a flat surface.

ANALYSIS OF PIAZZA DEL CAMPO: DIMENSIONS / ANGLES / DISTANCES

SUNRISE-SUNSET
June 22 - 4:31AM/7:55PM
Dec 22 - 7:42AM/4:35PM
- Latitude of City Form of Siena: 43° N 12° E
- Orientation of City Form of Siena: South 17° East
- Piazza del Campo Orientation: South 34° 50′ East
- Piazza Dimensions: 325′ x 475′

- Piazza Dimensions from East Wall to Center Drain: 261′- 8″
- Piazza Dimensions from North Wall to Center Drain: 263′- 4″
- Piazza Dimensions from West Wall To Center Drain: 215′- 9″
- Piazza Floor Slope Section Difference: 11.5′ to 16.4′
- Piazza Floor Slope Section Variations: East Medium High Side: 11.5′ West Medium High Side: 16.4′
- Palazzo Pubblico Heights: Central High Facade: 131.24′ Side Low Facades: 90.23′
- Torre del Mangia: Main Structure 316.6′
- Top of Bell Support: 328′

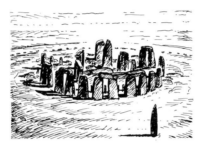

SUNDIALS, OBELISKS, AND TOWERS

Some of the earliest remaining structures are monuments to the human attempt to record the passage of time. The most notable, Stonehenge, was built in the third and second millennium B.C. and "keeps track of the sun's journey through the heavens." [Crouch, p. 350] Primitive societies learned that shadows cast from objects related to sun movements. "They no-

ticed that the shadow of an upright post became shorter as the sun rose in the heavens, and lengthened again as the sun set." [Boorstin, p. 27]

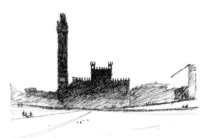

A similar effect occurs in the **Piazza del Campo** which was surfaced during the regime of "the Nine." The pattern is a huge open fan with radiating lines of travertine dividing off nine large areas of herringbone pattern, symbolically marking the hour divisions, providing a giant city-sized sundial, and forever reminding the Sienese of the powerful regime of "the Nine."

OBELISKS

Another example of this 'urban clock' can be seen wherever obelisks are placed in public places. The **Piazza dell'Annunziata in Venaria Reale** has an 'urban sundial.' A worn example of Torinese Baroque, this once lovely space is an excellent example of the subtle use of natural light in the urban setting by its north-south orientation and series of obelisks placed on the centerline of the space.

PILLARS OF LIGHT: REFLECTIVE TOWERS

The original building unit in Tuscany "as well as elsewhere in Italy during the Middle Ages was the tower." [J. Wood-Brown, p. 70] Perhaps for this reason, people identify with the towers of their respective towns. *Campanilismo* describes the "attachment to one's local tower." [Hook, p. 2] Originally serving as a lookout against enemies, it is an expression of the community's distinctive characteristics. Towers have been built in almost all cultures from time immemorial. "There came into being towers to honor a deity, towers symbolizing places of worship, towers as expression of spiritual and intellectual soaring." [Heinle & Leonhardt p. 7] These towers act as **pillars of light** as they reflect and bounce light down into dark streets and piazze.

SIENA: PIAZZA POSTIERLA "PILLAR OF LIGHT"

"The towers of medieval Siena suggest the ideal use of skyscrapers - spaced well apart and small in section. They do not shade each other and they do not unduly darken the streets and low buildings." [Hegemann & Peets, p. 145] Originally, connected pairs of towers lined the major streets of Siena providing a ceremonial quality to these streets. In fact, those remaining contribute greatly to the ambiance and the atmosphere of the place. When towers occur throughout a city such as **San Gimignano** and **Siena**, they introduce reflected light down into the streets and piazze. "The light is benign. It does not glare," it is, in fact, a "pleasant and flattering light." [Whyte 1988, p. 272] And that is because the towers are built of porous materials, such as brick, limestone, or travertine. "Instead of reflecting the sun

back in parallel ways, porous surfaces break up the rays and diffuse them. For urban design this has good consequences. The light is evenly reflected by the building that it falls upon and they are the easier to look at for this" reason. In fact, "some of them fairly glow." [Whyte 1988, p. 272] In Siena, the diminuitive **Piazza Postierla** heads the principal street, the via di Città, marked by the massive tower, the Palazzo Forteguerri. Remaining evidence suggests that it was connected with a half-arch/*arco rampante*, providing a bridge to a second tower of the Palazzo Borghesi. An awareness of surface treatment in this area is indicated by the fresco competition between Beccafumi and Sodoma on Palazzo Borghesi and Palazzo Bardi. [G. Bassi Giovannelli] Light is reflected down into the tiny piazza from the Forteguerri tower, with the light color of the stone contributing to an increase in the amount of reflected light. Daylight in the surrounding streets and piazza is extended late into the day as light rays graze the surface of this **pillar of light**.

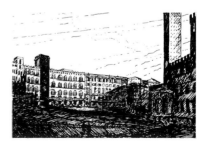

TORRE DEL MANGIA: PIAZZA DEL CAMPO, SIENA

When the shadow of the Torre del Mangia in Siena stretches across the piazza to coincide with the tower of the Palazzo Sansedoni, it is an amazing sight. Throughout the day, the tower reflects light on all four sides, and its crown of pale travertine reflects the last bit of daylight when all else is darkened in the town. The height and width of any tower placed to the south of a space are critical. The higher a building and the wider the resultant shadow, the greater the effects of the shadow. "For those on the receiving end the change is not one of degree; it may be absolute." [Whyte 1988, p. 258].

FOUNTAINS, CISTERNS, WELLS, MONUMENTS, AND STATUARY

Fountains and monuments in the medieval piazza are usually the focus of interest, counterbalancing other important edifices of the piazza. When an old fountain is replaced, invariably the same location or a slight realignment is selected and each of these places appears to have "its own meaning, its own history." [Sitte, p. 160] Some of the most successful in relationship to light are: Fontana Grande, Piazza IV Novembre, Perugia; Fonte Gaia, Piazza del Campo, Siena; La Cisterna, Piazza della Cisterna, San Gimigiano; and Fountain of Neptune, Piazza Signoria, Florence. Although fountains would have been located with access to water, they were usually situated near a major street, at an intersection, or at the major entrance to the square. "The public fountain was often a work of art, gratifying to the eye as well as slacking the thirst...and it was further a focus of sociability, providing an occasion for meeting and gossiping, since the fountain or pump...served as the local newscaster for a quarter." [Mumford, p. 295] **The cistern at Pienza** in **Piazza Pio II** still serves this need. The location of this cistern is especially interesting as it receives **shafts of light** early and late in the day in winter, and it is well located for sunlight throughout the day in summer in this early Renaissance space reminiscent of Michelangelo's Campodaglio. The truncated triangular plan invites shafts of light along the sides of the space.

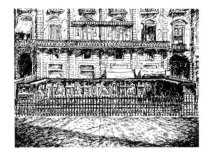

In **Siena** stands the weathered 19th century copy of the early **Fonte Gaia** fountain, designed and sculpted by "the most important Sienese sculptor of the early Renaissance," Jacopo della Quercia. It was for centuries, "a public watering place surrounded with marble reliefs and crowned with statues." [Hale, p. 271] It was named the *Fountain of Joy* for the elation that the Sienese expressed when water finally flowed from the spouts of its predecessor. It promoted the integration and interpretation of history, legends, myths, and virtues for good citizenship through allegorical art. Sitting Roman wolves with life-giving water flowing from their mouths, regenerate the standing pool of water and represent the Roman rebirth of the city; the mnemonic seashell catch basins contribute to the unified design of the space as they assist the memory in repetition of the Campo shape. Sculpted figures on the fountain and groupings depict biblical scenes; the four cardinal virtues, fortitude, prudence, justice, and temperance; and the three theo-

logical virtues, faith, charity, and hope. As a part of the entire civic ensemble, the *grande conchiglia* at the foot of the Campo also symbolizes the cycle of life as it returns the water to the sea.

The open-air fountain brought the lessons of the fresco *The Allegory of Good and Bad Government* from the interior walls of the Town Hall out into the open for all to see. This manner of intertwining history, fables, legends, myths, and beliefs of a community into the physical manifestations of civic art and architecture continues to extend these messages to citizens and visitors. It is an important part of the rituals and traditions of this community and continues to give 'meaning' and importance to the lives of its citizens. In the 19th century, the disintegrating Quercia fountain of porous marble, was replaced with a copy. The engineers of the new fountain adjusted its position to make a more regular relationship with the building behind it in an attempt to formalize the Campo in relationship to an Renaissance ideal.

The original location farther east would have received light longer in the day as it was also higher in elevation. Whether it had been located there originally to receive more light is not known. In addition, the old location would have been ideal because it was at the foot of the road from the north. The original placement, when viewed in retrospect, represented the freedom and spontaneity of the Middle Ages far more than does the existing formalized location. The original location for the early Renaissance Fonte Gaia was more congruent and better related to the Campo's asymmetrical space. Due to the unusual shape of the plan and the eccentricity of the location of the old fountain, visually the old location acted as the centroid of this asymmetrical space. As the tower shadow moves across the fountain today, its location in relation to the shadow calls attention to its part in this urban clock.

SPOTLIGHTING MONUMENTS: WITH "SHAFTS OF LIGHT"

In **Florence**, one of the finest locations of any monument is so successful, it leaves no doubt about the rationale of its selection. As Sitte said about it, "everything always harmonized beautifully." [Sitte, p. 158] **Michelangelo's David** is placed in line with other statues and the Fountain of Neptune in front of the Palazzo Vecchio in Florence's **Piazza della Signoria**. The stone from which David is carved, an opalescent Carrara marble, is completely profiled by the dark rusticated stone of the Palazzo Vecchio, its background. "One could not imagine anything better to set off all the lines of the body than the background of the dark and monotonous, yet powerfully rusticated masonry of the palace." [Sitte, p. 156] Looking at the most extreme case, the winter solstice provides an excellent **shaft of light** into the Piazza della Signoria from the courtyard of the Gallery of the Uffizi. All of the statues and the fountain are captured in this winter light for about an hour at mid-day. Another example is during the summer solstice, when a **shaft of light** from the late western sun spotlights David against the dark background at the end of a vista. This **spotlighting** is an exceptional example of the use of natural light in the Italian Piazza.

93

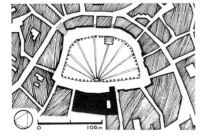

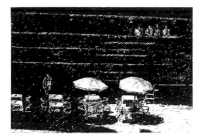

ALTERATION:
OF THE SUNLIGHT

Both inside and out, there are daily and seasonal needs to alter and control sunlight, and a variety of "switches" have been developed. One of the most creative devices is the European **shutter** that provides interior and exterior "filter, connector, barrier, or switch" variations in air, light, privacy, and sound control for interior spaces. [Reynolds, p. 59] In exterior spaces, for instance, in **Vigevano** a contrasting white is used by the cafes in metal tables and **umbrellas**, complementing the rich earthen colors of **Piazza Ducale**. The earthen colors of **awnings** and **umbrellas** in **Siena** give a delightful touch of color and translucence in the areas that receive the most sun. The **urban drapery** lining the arches of the colonnade in **Piazza San Marco** in **Venice** is striking for its simplicity and the manner in which it augments light. When the drapery glows from the sunlight and billows from the sea breezes, time is suspended and one feels a connection with those who have gone before.

SEATS, STEPS, AND STAIRS:
"PLACES TO SIT"

Sun, wind, temperature, and aesthetics help people choose where to sit in urban open spaces. American sociologist William Whyte has found that "the most popular plazas tend to have considerably more sitting space than the less well-used ones." [Whyte 1980, p. 27].

At **Arezzo**, on the west end of the Piazza Grande are two sets of wonderful stairs for sitting that receive sunlight through the morning and early afternoon. A graceful, half-round stair blending into the slope of the piazza floor leads up to the town hall. The second accommodates the extreme grade change around the square's fountain with a 'lightening bolt' series of steps. At **Cortona**, in Piazza Repubblica, people sit in small cafes or on the monumental staircase that leads up to the town hall.

In **Firenze**, in Piazza Signoria they sit in constant shade on the base steps of the Loggia della Si-

gnoria, and those who can afford to, sit in open-air cafes.

In **Portofino's** Piazza Marinara, people sit on long moveable benches, on the wall of the quay and in the cafes and restaurants that surround the harbor.

In **Perugia**, people enjoy sitting across the broad foundation steps of the Duomo as it straddles the head of Corso Vannucci.

In **San Gimignano**, with three connected piazze, people sit on seats at the bases of public buildings, in small cafes with awnings, and on the wide bank of steps that lead up to the Cathedral.

In **Siena**, tourists sit in bars, cafes, and on the concave floor of the brick **Piazza del Campo**. The cafes and bars line the piazza's sunny east, north, and west sides. The clientele of the Fonte Gaia to the west, enjoy direct sun as they sip their morning *cappuccino;* later, with the sun behind them, they are treated to a commanding view of the evening light on the Campo as they sip their aperitifs.

In **Todi**, at the Piazza del Popolo, people sit on the monumental stair leading up to the cathedral and on the steep staircase to the town hall. In **Venice**, at Piazza San Marco, people sit in expensive cafes, or on the few low steps at the base of the arcaded colonnade that lines three sides of the piazza. In the ancillary space next to the Basilica, people sit on steps, while their children clamber over old stone lions.

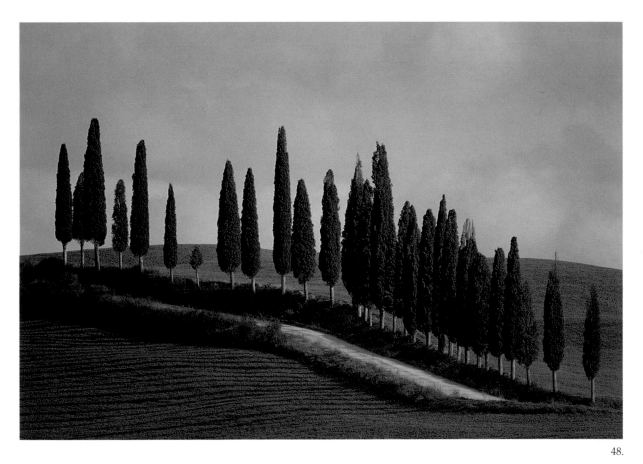

48.

As [trees] keep the shape of the wind even when the wind
has fled and is no longer there
So words [or walls] guard the shape of man even
when man has fled and is no longer there.

George Seferis

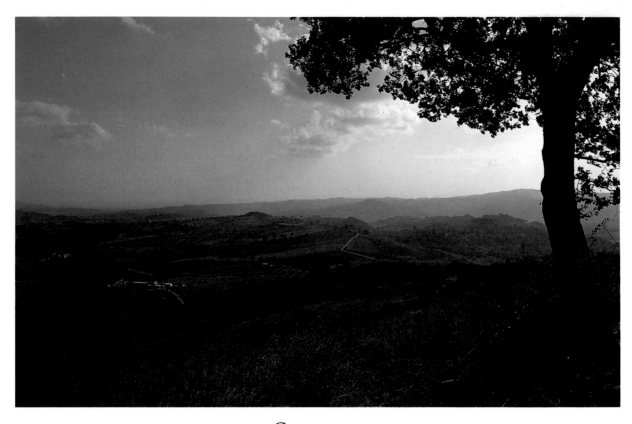

CONCLUSION

The examples presented explain why Siena and other hill towns are perfect models for the study of natural light. They provide an opportunity to observe a variety of architectural factors working in unison with the elements of nature. Since "the illumination of cities is one of the great untapped reservoirs of modern urban design," [Spreiregen, p. 223] this approach provides great possibilities for improvement in the manner in which light is considered in the design of cities. It is an enriching experience to walk through the streets of hill towns, especially rewarding for those in the visual disciplines of art, architecture, design, sculpture and city planning; and this work is meant to build awareness of light, to define and illustrate examples of urban light which can inspire universal awareness and Knowledge of natural light.

Leonardo Benevolo in *The History of the City* states that it is important to study the cities that have a "continuing link" between the Middle Ages and the present day. "What should be studied is not a dead city but a city that has partly survived within a modern urban complex."

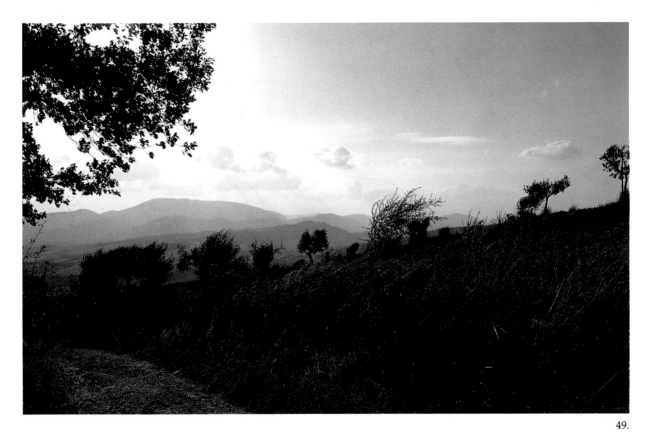

49.

Furthermore, "a living city such as Siena or San Gimignano cannot be cleared (by archaeologists) to make way for scientific research... we, therefore, have to make use of more restricted and less certain documentation, but this can be compensated for by direct experience: for example, it is possible to walk through the Piazza del Campo in Siena... down the streets of Perugia... and meet the descendents of the medieval inhabitants, who sometimes still live in the same houses and work in the same workshops as their ancestors." [Benevolo, pp. 253, 254].

In *Culture and Society in Italy, 1290-1420*, John Larner graphically describes the difficulties of appreciating the art and architecture of another era in time and place. He states that, "these works demand of us a knowledge and an imaginative force which, however strong, can never wholly and satisfactorily recreate the reality of what existed when they were first made." Larner says it is "difficult to see a building of the fourteenth century as it was in the fourteenth century," and to understand it in the context of the social and cultural ramifications of that era,

"when we enter it, not as a citizen, proudly coming to the visible symbol of our city, but as a tourist, fumbling for an entrance - fee at the door." [Larner, p. 2] In Siena, since the medieval city remains almost entirely intact it is possible to imagine oneself walking the streets during another era.

"Siena, in the exemplary unity of its town-planning, represents a monument of history and art." [Cairola & Carli, p. 9] Due to the cohesive and historic richness of its architecture, Siena is an excellent contextural example to use for young designers, as they can be given the difficult opportunity to design within an existing atmosphere of architectural excellence. For the same reason, Siena inspires scholars, student or professional alike. For the advanced scholar, Siena and cities like it can give a renewed impetus to the pursuit of excellence in architecture.

This exhibition and catalogue have been designed to present experientially to the viewer and the reader the phenomena of natural light within the Gothic civic realm. By focusing on light and its effect in the environment, it has

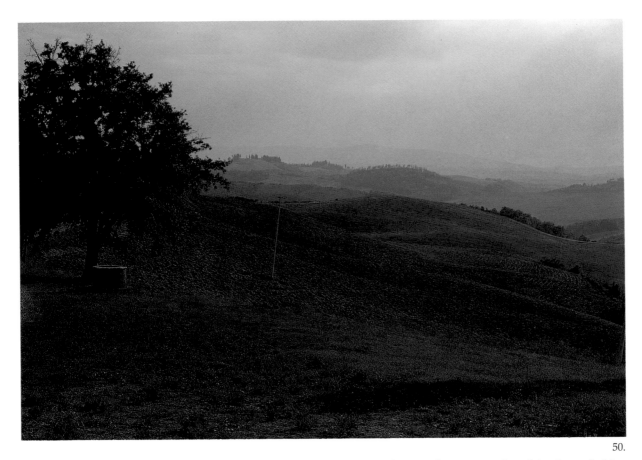

50.

been possible to document the elements of architecture and to record the actions of people in relationship to its effects.

With concentrated study of natural light, this work has facilitated a comprehensive study of the Italian milieu. During the research phases study poignantly revealed historic and contemporary differences in American and European concepts about the founding of cities and the development and purpose of urban space.

Following the concepts of the Gothic era which taught its citizens within the physical constructs of its architecture, the objective of this work and its subliminal didactic approach is to increase an understanding and an awareness of light and its relationship to the urban environment. It is intended that an awareness of the aesthetics of light and a pragmatic understanding of its effects will inspire citizens, politicians, professional designers and scholars who are involved in design decisions critical to our cities and countrysides.

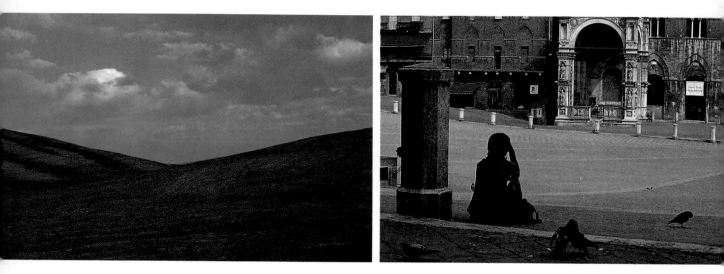

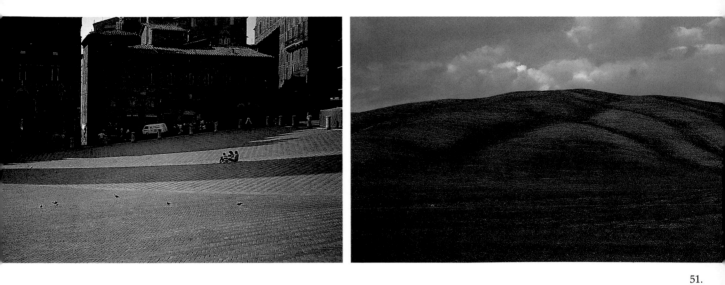

51.

"Earth to Earth, dust to dust, ashes to ashes..."

Book of Common Prayer

Enchanting recollections of travel form part of our most pleasant reveries. Magnificent town views, monuments and public squares, beautiful vistas all parade before our musing eye, and we savor again the delights of those sublime and graceful things in whose presence we were once so happy.

Camillo Sitte

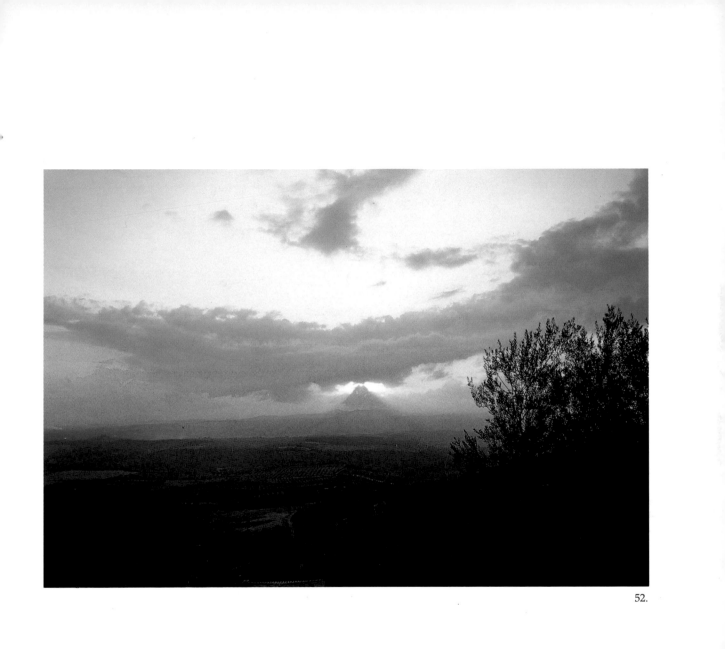

52.

Acknowledgements

It is with profound gratitude that I thank the many individuals and organizations which have facilitated this project culminating in the Exhibitions in the Cortile del Podestà and the Palazzo Patrizi for the Comune di Siena. Just as the Exhibition is two-fold, this thank you extends in two directions, to Siena and to Cal Poly and to the citizens of Siena, Italy and San Luis Obispo, California.

In Siena, in honor of her mother, Signora Pia Bassi of the Bassi Book Shop, Grazia Bassi Giovanelli has graciously contributed to the publication of this catalogue. Contributions from Comune di Siena, Banca Toscana, Università di Siena, and the Università per Stranieri have also been essential.

Various people in the Comune di Siena have made meaningful contributions, in the process overcoming communication barriers of language and distance. Many remain unnamed but have nevertheless been helpful. Among the Comune, I wish to give special thanks to the following: The Mayor, Pierluigi Piccini; The City Councillors, Saverio Carpinelli and Alessandro Vigni; the staff of the Office of Culture; Alessandro Ferrari of Centro Storico; Jill Gilbert and Valerio Riccucci. Without the encouragement of my friends, Carla Rosi, Dr. Ahmed Nagi, Enzo Santini and Professor Pietro Paolo Cannistraci, the tasks in Siena would not have been possible.

In California, the unwavering support of President Warren J. Baker and Mrs. Baker, his administrative staff and the Cal Poly Foundation, have been essential to the nurturance and culmination of this project. The continued support and advice from Margaret Cardoza of Grants Development and Dr. Jeanne La Barbera of the University Union Galerie have been invaluable.

The College of Architecture deserves a particular thank you. In the Department of Architecture, Professors David Brodie, Don Swearingen, and Dr. John Lange have contributed significantly to this project. Carol Zsadanyi has earned notable mention for clerical assistance. During the research phase, members of the Physics Department of Cal Poly; Drs. Theodore C. Foster, John E. Poling, and Rich Saenz provided information relative to the Phenomena of Light section. Glenn Whaley, reference room librarian provided information valuable to the completion of many parts of the manuscript. Cathleen Matthews of Maps and Documents proved very helpful.

The University of Oregon deserves special credit for inspiring 'this work' as its theoretical emphasis amply complemented the pragmatic education I gained at the University of Cincinnati. Special gratitude is extended to Dean Jerry Finrow and Prof. John Reynolds of Oregon who have acted as long-term advisors. In the study of the orientation of cities and urban open spaces; Marc Levy of the Map and Aerial Photography Library at the University of Oregon provided crucial maps. B.J. Novitski of Eugene, Oregon, supplied essential editorial assistance.

In San Luis Obispo, several townspeople willingly donated materials and monies to this project. Most notably, Mrs. Beth Law of Law's Hobby Center; Jim Rankin of Kinko's; Gene Gay of Progressive Plastics; George Palmer of Central Coast Fabrications; and John Barrett of California Men's Colony.

Grant support from Cal Poly commenced in 1983 and awards followed from notable foundations. L.J. Skaggs and Mary C. Skaggs Foundation awarded seed grants critical to the development of the research photography in 1985, 1986, and 1987. In 1985 and 1990 the Graham Foundation for Advanced Studies in the Fine Arts provided funds for continuation of the research, shipping costs and for student assistants in Siena. In 1991, the National Endowment for the Arts, Washington, D.C., awarded support for the completion of this manuscript. Without these awards and the continued support from Siena and Cal Poly this project would never have come to fruition. It is this support, a form of international goodwill and cooperation, for which I am grateful.

BIBLIOGRAPHY: NATURAL LIGHT & THE ITALIAN PIAZZA

Alexander, Christopher, *A New Theory of Urban Design*, Oxford University Press, New York and Oxford, 1987.

Bachelard, Gaston, *the Poetics of Space*, Beacon Press, Boston, 1969, / *La poetique de l'espace*, Presses Universitaires de France, 1958.

Bassi Giovannelli, Grazia, Conversation in Siena, 1992.

Benevolo, Leonardo, *The History of the City*, The MIT Press, Cambridge, Massachusetts, 1981.

Boorstin, Daniel, *The Discovers, A History of Man's Search to Know His World and Himself*, Random House, New York, 1983.

Borse, Franco e Pampaloni, Geno, *Le Piazze, Monumenti D'Italia*, Istituto Geografico de Agostini, Novara, 1975.

Braunfels, Wolfgang, *Mittelalterliche Stadtbankunft, in der Toskana*, Verlag Gebr. Mann, Berlin, 1966.

Brogi, Andrea and Cavallero, Daniela Gallavotti, *Lo Spedale Grande di Siena, I, Considerazioni sulla formazione della cittá di Siena*, la casa Usher, Firenze, 1987.

Cairola, Aldo and Carli, Enzo, *The "Palazzo Pubblico" of Siena*, Editalia Monte Dei Paschi Di Siena, Roma, 1964.

Cervellati, Pier-Luigi, *Preservation with Participation, The City as Memory*, Historic Preservation, Bologna, Italy, N.D.

Cesarini, Paolo, *Terra di Siena*, EDITALIA Edizioni d'Italia, Roma, N.D.

Chambers, Isobel M., *Piazzas of Italy*, The Town Planning Review, Volume XI No. 4, Liverpool University Press, Liverpool, England, February, 1926.

Cotterell, Arthur, *The Macmillan Illustrated Encyclopedia of Myths and Legends*, Macmillan Publishing Company, New York, 1989.

Crouch, Dora P., *History of Architecture, Stonehenge to Skyscraper*, McGraw-Hill Book Company, New York, 1985.

Culverwell, Nathaniel, *An Elegant and Learned Discourse of the Light of Nature*, Introduction by Robert A. Greene and Hugh MacCallum, University of Toronto Press, Toronto and Buffalo, 1971.

Eco, Umberto, *ART and BEAUTY in the MIDDLE AGES*, Yale University Press, New Haven and London, 1986 / *Sviluppo dell'estetica medievale in Momenti e probleme di storia dell'estetica*, Marzprate Editore, 1959.

Elsen, Albert E., *Purposes of Art, An Introduction to the History and Appreciation of Art*, Third Edition, Holt, Rinehart and Winston, Inc., New York, 1972.

Falassi, Alessandro and Dundes, Alan, *La Terra in Piazza, An Interpretation of the Palio of Siena*, University of California Press, Berkeley, 1975.

Feininger, Andreas, *Light and Lighting in Photography*, Amphoto, American Photographic Book Publishing Co., Inc., Garden City, New York, Prentice-Hall, Englewood Cliffs, New Jersey, 1976.

Hale, J. R., *A Concise Encyclopaedia of the Italian Renaissance*, Oxford University Press, New York and Toronto, 1981.

Hanson, *Jacopa della Quercia's Fonte Gaia*, Clarendon Press, Oxford, 1965.

Hegemann and Peets, *American Vetruvius : An Architects' Handbook of CIVIC ART*, Princeton Architectural Press, New York, 1988.

Heinle, Erwin and Leonhardt, Fritz, *TOWERS, A Historical Survey*, Deutsche Verlags-Anstalt GMBH, Stuttgart, 1989.

Hewison, Robert, *John Ruskin, The Argument of the Eye*, Princeton University Press, Princeton, New Jersey, 1976.

Hewitt, Paul G., *Conceptual Physics*, 3rd Edition, Little, Brown and Company, Boston, 1977.

Hills, Paul, *THE LIGHT OF EARLY ITALIAN PAINTING*, Yale University Press, New Haven and London, 1987.

Hook, Judith, *Siena, A City and Its History*, Hamish Hamilton, London, 1979.

Katz. D., *The World of Colour*, printed by Edinburgh Press, translated from the German by R B. MacLeod and C.W. Fox, London, 1935, Johnson Reprint Corp., New York, 1970.

Keller, H., *Italienische Kunstlandschaften*, Munich, 1965.

Kidder-Smith, G.E., *Italy Builds, L'Italia Costruisce, The Modern Architecture and Native Inheritance*, Reinhold Publishing Corporation, New York, 1954.

Komendant/Kahn, Louis I. Kahn, *Eighteen Years with Architect, Louis I. Kahn*, Aloray Press, Englewood, New Jersey, 1975.

Lakeman, Sandra Davis, *Natural Light and the Italian Piazza, An Investigation in Human Scale Urban Environments*, The Discipline of Architecture : Inquiry through Design, American Collegiate Schools of Architecture, Vancouver, 1985.

Lam, William M.C., *Sunlighting as Formgiver for Architecture*, Van Nostrand Reinhold, New York, 1986.

Langer, Suzanne K., *Feeling and Form*, Charles Scribner's Sons, New York 1953.

Langer, Suzanne K., *Problems of Art: Artistic Perception and "Natural Light,"* Charles Scribner's Sons, New York, 1957.

Larner, John, *Culture and Society in Italy 1290-1420*, Charles Scribner's Sons, New York, 1971.

Lawrence, D. H., *Etruscan Places*, Martin Secker, London, 1932, Olive Press, London, Nuova Immagine Editrice, Siena, 1986.

Lobell, John, Kahn, Louis I., *Between Silence and Light, Spirit in the Architecture of Louis I. Kahn*, Shamnhala, Boulder, Colorado, 1979.

Mach, Ernst, *The Analysis of Sensations, and the Relation of the Physical to the Psychical*, Fifth German Edition, Dover Publications, New York, 1959.

Mack, Charles R., *Pienza, The Creation of a Renaissance City*, Cornell University Press, Ithaca and London, 1987.

Minnaert, M., *The Nature of Light and Colour in the Open Air*, Dover Publications, Inc., New York, 1954.

Morini Mario, *Atlante di Storia dell'Urbanistica*, (dalla Preistoria all'inizio del secolo XX) Editore Ulrico Hoepli, Milano, 1983.

Mumford, Lewis, *The City in History, Its Origins, Its Transformations, and Its Prospects*, A Harbinger Book, Harcourt, Brace & World, Inc., New York, 1961.

Norberg-Schulz, Christian, *Meaning in Western Architecture*, Rizzoli, New York, 1981.

Pius II, *Memoirs of a Renaissance Pope : The Commentaries of Pius II*, Translated by Florence Alden Gragg, Edited by Leona C. Gabel, Capricorn Books, New York, 1959.

Rainwater, Clarence, *Light and Color*, Golden Press, Western Publishing Company, New York, 1971.

Ratliff, Floyd, *Contour and Contrast*, Scientific American, June, 1972.

Reed, Arden, *Signifying Shadow*, VIA 11, Architecture and Shadow; The Journal of the Graduate School of Fine Arts, University of Pennsylvania, Philadelphia, 1990.

Reynolds, John, S., Lecture: University of Oregon, [McQuinness, Stein, Reynolds], *Mechanical and Electrical Equipment for Buildings*, 6th Edition, John Wiley & Sons, New York, 1980.

Ruskin, John, *The Seven Lamps of Architecture*, The Noonday Press, A Subsidiary of Farrar, Straus and Cudahy, New York, 1961.

Sitte, Camillo, *City Planning According to Artistic Principles*, Vienna 1889, Translated from the German by George R. Collins and Christiane Crasemann Collins; and accompanying text: *Camillo Sitte: The Birth of Modern City Planning* by George R. Collins and Christiane Crasemann Collins, Rizzoli, New York, 1986.

Solomon, Barbara Stauffacher, *Green Architecture and The Agrarian Garden*, Rizzoli, New York, 1988.

Spreiregen, Paul D., AIA, *Urban Design: The Architecture of Towns and Cities*, for The American Institute of Architects, McGraw-Hill Book Company, New York, 1965.

Stopani, Renato, *La via Francigena nel Senese, Autori Vari, Storia et Territorio*, Salimbeni, 1983/1984: n.1, Sestan, Ernesto, Siena avanti Montaperti, Italia Medievale, Napoli, 1968.

Trachtenberg, Marvin and Hyman, Isabelle, *Architecture, from Prehistory to Post-Modernism*, Prentice-Hall, Inc., Englewood Cliffs, New Jersey, Harry N. Abrams, Inc., New York, 1986.

Touring Club Italiano:
Piante di attraversamento di 170 citta', Milano, 1956.
PIAZZE D'ITALIA, Italia meravigliosa, Milano, 1971.
Citta' da Scoprire, Guida ai Centri Minori, Italia Settentrionale, Milano, 1983.
Citta' da Scoprire, Guida ai Centri Minori, Italia Centrale, Milano, 1984.
Guida Illustrata, Italia, Milano, 1984.

Tuan, Yi-Fu, *Topophilia, A Study of Environmental Perception, Attitudes, and Values*, Prentice-Hall, Inc., Englewood Cliffs, New Jersey, 1974.

Vandoyer, Jean-Louis, Foreward to *ITALY*, Edited by Ogrizek, Dore', Whittlesey House, McGraw Hill Book Company, Inc., New York, N.D.

Waley, Daniel, *The Italian City-Republics*, Third Edition, Longman, London and New York, 1988.

Wortz, Melinda, Introduction for *Light and Space*, by James Turrell, Whitney Museum of American Art, New York, N.D.

Westinghouse, *Lighting Handbook*, Westinghouse Electric Corporation, Lamp Divisions, Bloomfield, New Jersey, January, 1976.

Whyte, William H., *The Social Life of Small Urban Spaces*, The Consevation Foundation, Washington, D.C., 1980.

Whyte, William H., *CITY, Rediscovering the Center*, Doubleday, New York, 1988.

Willis, Lucy, *Light, How to See It, How to Paint It*, North Light Books, Cincinnati, Ohio, 1988.

Wood-Brown, J., *The Builders of Florence*, Methuen & Co., London, 1907.

Zucker, Paul, *Town and Square, from the Agora to the Village Green*, The MIT Press, Cambridge, Massachusetts, and London, England, 1959.

Natural light and the Italian Piazza: List of Plates

SITE ORIENTATION OF ITALIAN TOWNS: On Water, Flat and, Hillside

Although there are towns which historically have mandated a northern exposure, few exist and by far the dominate orientation is to the South. A listing of the most prominent existing towns shows a distinct knowledge of the ways, patterns, and the results of Natural Light. In compiling these lists, the cities were selected as successful working cities with a principal piazza which was a good receptor of light. Their orientation was subsequently researched. Almost every town listed has a Southern orientation and predominantly a Southeastern orientation. The fact that these cities have remained as some of the most beautiful, active and viable communities in todays' world, should be attributed at least in part to their initial Site Selection, Relationship to the Topography, and Orientation to the Sun. It substantiates the rationale regarding the importance of site planning in relationship to the Sun and it proves the necessity of understanding and relating to the Sun. The following chart compiled from experiential research, available texts on the Italian Piazza, atlases, and maps, shows three site situations; the Italian town *On the Water, On Flat Land*, and *On the Hillside*. In addition, a table listing latitudes and longitudes is included.

SITE ORIENTATION OF ITALIAN TOWNS

ON THE WATER:	ORIENTATION OF THE SITE	
Amalfi	Porto	SE
Atrani	Porto	SE
Bari	Porto Vecchio	SE
Camogli	Porto Vecchio/City Form	SW
Deiva Marina	Waterfront	SW
Genova	Porto Vecchio & Porto Entry	SW-S-SE & SE
La Spezia	Porto	SE
Locarno	Imbarcadero	SE
Lugano	Imbarcadero	SE
Monoco	Porto	SE
Napoli	Porto Beverello & Merchantile	SE & SE
Portofino	Rapallo Bay	SE
Porto S. Stefano	Porto	NE
Porto Giglio	Porto Giglio	SE
Salerno	Porto	SE
Santa Margherita	Porto	SE
Venezia	City Form	E/W
ON FLAT LAND:	**ORIENTATION OF THE SITE**	
Ascoli Piceno	City Form	E/W
Firenze	City Form	E/W
Foligno	City Form	E/W
Lucca	City Form	E/W
Pompei	City Streets	SE/NW & SW/NE
Roma	City Form	NW/SE
Sabbioneta	City Form	E/W
Venaria Reale	City Form	SE/NW
Vigevano	City Form	E/W
ON THE HILLSIDE	**ORIENTATION OF THE SITE**	
Arezzo	City Form	SE/NW
Assisi	City Form	E/W
Cortona	City Form	SE/NW
Gubbio	City Form	SE/NW
Loreto	City Form	E/W
Orvieto	City Form	E/W
Perugia	City Form	N/S by SW/NE
Pienza	City Form	E/W
Pitigliano	City Form	E/W
San Gimignano	City Form	N/S
Spello	City Form	N/S
Spoleto	City Form	SW/NE
Siena	City Form	SE/NW
Todi	City Form	SW
Terni	City Form	SW/NE
Urbino	City Form	N/S
Verona	City Form	E/W
Volterra	City Form	SE/NW

THE LATITUDE AND LONGITUDE OF ITALIAN TOWNS

ON THE WATER:	LATITUDE	LONGITUDE
Camogli	44° 21' N	9° 09' E
Deiva Marina	44° 13' N	9° 30' E
Genova	44° 25' N	8° 12' E
Portofino	44° 18' N	9° 12' E
Porto S. Stefano	42° 26' N	11° 6' E
Porto Giglio	42° 23' N	10° 54' E
Santa Margherita	44° 19' N	9° 12' E
Venezia	45° 26' N	12° 20' E
ON FLAT LAND:	**LATITUDE**	**LONGITUDE**
Ascoli Piceno	42° 52' N	13° 35' E
Faenza	44° 17' N	11° 53' E
Firenze	43° 46' N	11° 15' E
Foligno	42° 57' N	12° 43' E
Lucca	43° 51' N	10° 29' E
Massa Marittima	43° 03' N	10° 53' E
Marostica	45° 45' N	11° 40' E
Matelica	43° 15' N	13° 01' E
Pisa	43° 43' N	10° 24' E
Pompei	40° 45' N	14° 27' E
Roma	41° 54' N	12° 30' E
Sabbioneta	45° 00' N	10° 29' E
Torino	45° 04' N	7° 40' E
Venaria Reale	45° 08' N	7° 38' E
Verona	45° 26' N	10° 59' E
Vicenza	45° 33' N	11° 32' E
Vigevano	45° 19' N	8° 51' E
ON HILLSIDES:	**LATITUDE**	**LONGITUDE**
Arezzo	43° 28' N	11° 53' E
Assisi	43° 04' N	12° 37' E
Bergamo	45° 42' N	9° 40' E
Castell'Arquato	45° 05' N	9° 52' E
Castel Giglio	42° 23' N	10° 54' E
Cortona	43° 17' N	11° 59' E
Gubbio	43° 21' N	12° 35' E
Loreto	43° 26' N	13° 36' E
Massa Marittima	43° 03' N	10° 53' E
Orvieto	42° 43' N	12° 06' E
Perugia	43° 07' N	12° 23' E
Pienza	43° 04' N	11° 40' E
Pitigliano	42° 38' N	11° 40' E
San Gimignano	43° 28' N	11° 02' E
Spello	42° 59' N	12° 41' E
Spoleto	42° 44' N	12° 44' E
Siena	43° 19' N	11° 19' E
Todi	42° 47' N	12° 24' E
Urbino	43° 43' N	12° 38' E
Vicenza	45° 33' N	11° 32' E
Volterra	43° 24' N	10° 52' E